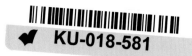
SURREALISM

IN THE TATE GALLERY COLLECTION

cover
Salvador Dalí
Lobster Telephone 1936

ISBN 0946 590 923
Published by order of the Trustees 1988
for the collection display, 24 May 1988 – 4 March 1989

Published by Tate Gallery Liverpool, Albert Dock, Liverpool L3 4BB
Designed by Pentagram Design Limited
Colour origination by Palatine Graphic Arts
Printed in Great Britain by Lund Humphries Printers

Works by Hans Bellmer, René Magritte, Joan Miró and Francis Picabia
have been reproduced by permission of © ADAGP, Paris/DACS, London 1988,
works by Giorgio de Chirico, Paul Delvaux, Max Ernst and Pablo
Picasso by permission of © DACS 1988, works by Jean Arp and Paul Klee
by permission of © COSMOPRESS, Geneva/DACS, London 1988, and works by
Salvador Dalí by permission of DEMART PRO ARTE B.V./DACS 1988.

CONTENTS

The Trustees and Director are indebted to the Merseyside Development Corporation for their major contribution and to the following for their generous financial support:

CAPITAL COSTS OF
TATE GALLERY LIVERPOOL

Founding Benefactor
The Wolfson Foundation

Founding Patrons
The John S Cohen Foundation
The Esmee Fairbairn Charitable Trust
Granada Television and Granada Foundation
The Henry Moore Foundation
The Moores Family Charitable Foundation
The New Moorgate Trust Fund
Ocean Transport and Trading plc (P H Holt
Charitable Trust)
Plessey Major Systems, Liverpool
The Sainsbury Family Charitable Trusts
The Bernard Sunley Charitable Foundation

Other Major Supporters
Arrowcroft Group Ltd
Barclays Bank plc
The Baring Foundation
Deloitte Haskins and Sells
Higsons Brewery plc
The John Lewis Partnership
The Liverpool Daily Post and Echo Ltd
The Manor Charitable Trust
The Pilgrim Trust
Pilkington plc
The Eleanor Rathbone Charitable Trust
Royal Insurance UK and Royal Insurance plc
Trustee Savings Bank Foundation
United Biscuits UK Ltd
Whitbread & Co plc

Contributions have also been received from
The Beausire Trust
Blankstone Sington and Company
British Gas plc
Commercial Union Assurance Company plc
GMB
The Goldsmiths' Company
The Grocers' Company
Mrs Sue Hammerson
ICI
The Idlewild Trust
J P Jacobs
Kodak Ltd
The Members of Lloyd's and Lloyd's Brokers
Sir Jack and Lady Lyons
Mason Owen and Partners
The Mercers' Company
Provincial Insurance
The Rogot Trust
Royal Bank of Scotland plc
Schroder Charity Trust
John Swire and Sons Ltd
The Twenty-Seven Foundation
Vernons Organisation Ltd
An anonymous donor

SPONSORS OF
TATE GALLERY LIVERPOOL 1988 – 9
Andrews Industrial Equipment Ltd
Ashton-Tate plc
Ivor Braka Ltd
British Rail
Bymail
DDB Needham Worldwide
Fraser Williams Group
Granada Business Services
Greenall Whitley plc
The Henry Moore Foundation
IBM United Kingdom Trust
ICI Chemicals and Polymers Limited
The Laura Ashley Foundation
Merseyside Task Force
MoMART
Mont Blanc
P & P Micros Ltd
Patrons of New Art,
Friends of the Tate Gallery
Parkman Consulting Engineers
Pentagram Design Limited
Tate Gallery Foundation
Tate Gallery Publications
Tate Gallery Restaurant
Thames and Hudson Ltd
Save and Prosper
Unilever plc
Volkswagen

PREFACE

Surrealism was principally a European intellectual escapade, promoted in Paris in the 1920s by writers, painters and film makers. It had developed from an international avant-garde brought together during and after the first World War under the various banners of Dada. Surrealism never intended to be only an art movement, and its success, although not entirely welcome to the Surrealists themselves, has pervaded much of contemporary culture. They believed that releasing the unconscious and appreciating what they considered the marvellous in the everyday would lead them to a higher reality – a 'sur-reality'.

Few English artists were willing to pursue this dangerous course whole-heartedly; Roland Penrose was an isolated exception. The son of a painter, Penrose lived in Paris and became a close friend of Picasso, Miró, Breton, Eluard and others. He had a walk-on part in the Dalí/Buñuel film *L'Age d'or* in 1928, for example, because he claimed, with characteristic modesty, that he was the only person with a dinner jacket whom they knew at the time

Penrose championed Surrealism in England and was the principal organiser of the *International Surrealist Exhibition* in London in 1936. There he showed the collection he had been making for several years alongside the artists' more recent works. Photographs of the exhibition installation show the most extraordinary combinations of what are now highly prized works scattered in museums in Europe and America, which after the exhibition were hung together in Penrose's house as he 'looked after them' temporarily for the artists.

The Tate's surrealist group is its strongest holding of modern art and it owes much to Penrose's foresight and 'eye'. He owned for example, the paintings 'Celebes' and 'Pietà' by Max Ernst, 'The Uncertainty of the Poet' by de Chirico, and he helped the Tate Gallery, when he was a Trustee, to acquire Picasso's 'Three Dancers'. His son Antony has kindly lent works to this display.

We are most grateful to all the lenders of works of art and to the Liverpool Museum of the National Museums and Galleries on Merseyside, the Science Museum, the Haworth Art Gallery in Accrington and the private collectors who have enabled us to make the display more representatively surrealist. Dawn Ades, senior lecturer in the History of Art at the University of Essex and Michael Sweeney, who is curating the Penrose collection, have contributed essays. Joanne Bernstein has compiled the notes on the works.

Sir Alan Bowness
Director
Tate Gallery

TRANSFORM THE WORLD
. . .CHANGE LIFE

Dawn Ades

Surrealism's greatest worldly success, the popularity of its art, has also been its greatest threat. The danger was to the surrealist project as a whole, and was perceived by André Breton as early as 1929, when he wrote, five years after the founding of the movement, 'The approval of the public is to be avoided like the plague.' (*Second Surrealist Manifesto*). But why should public approval be a threat, and isn't there something contradictory for a movement committed to Marxism to seek to guard its privacy? On one level, public acceptance meant acceptance by the bourgeoisie, and therefore incorporation within a cultural system and set of values to which Surrealism was opposed. But beyond the neutralising effect of such success, Breton feared the public spread of a simplified, diluted, confused and above all static version of surrealist ideas and modes of expression. 'Surrealism', he wrote in the *Second Surrealist Manifesto*, 'is still in a period of preparation', a period that would last, as far as he was concerned, for the rest of his life.

One problem, as far as the fame of its art is concerned, is that this has sometimes been taken as the full extent of Surrealism's activity. This is ironic, given that what attracted and continued to attract artists to the movement was the fact that it provided a centre of intellectual debate, poetic experiment and political radicalism. It was, in other words, the very opposite of a 'laboratory of formal ideas', with a narrow view of a self-contained art, which was how many artists viewed, for instance, post-war Cubism. At the same time, of course, Surrealism proved remarkably fecund in its enlargement of the visual and physical resources of the artist. From the perspective of Surrealism itself, this also on occasion was seen as a danger, if the artist started pursuing formal and technical experiments, provoked by the search for methods equivalent to those of surrealist practices in writing, such as automatism, for their own sake. So Breton expressed reservations about Miró who, in 'giving himself up utterly to painting,

and to painting alone', was paying insufficient attention to the 'profound value and significance' of the automatism that was the starting point of his procedure. Internal problems between the painters, who tended to maintain some distance from the theoretical heart of Surrealism, and the movement's leader Breton, were not uncommon. The question also arises, of course, as to who is to say if a picture is or is not surrealist. The work of some artists was accepted as such although they were not members of the movement: de Chirico is the most famous example, whose canvases of the period between c.1911 and 1919 were much admired by the Surrealists and were key influences on surrealist artists like Ernst, Tanguy, Magritte and Dalí. Paul Klee, too, was admired, and his work was included in the first surrealist exhibition in Paris in 1925. And Picasso, more than any of the artists in Breton's immediate circle, was taken as the guide for surrealist art. On the other hand, there are artists who ceased to belong to the movement, or became unacceptable to it, who continued to describe their work as surrealist. The most notorious example of this is Salvador Dalí. While the visionary canvases of 1929, which Breton once said had the same character of revelation as Max Ernst's 'Pietà or Revolution by Night', or as Miró's 'Tilled Field', were welcomed as a major new venture for Surrealism by this new recruit, by the end of the 1930's, the situation had reversed. Dalí was seen as sinking into a kind of surrealist academicism, and his elaborate double images of this period, like 'Swans Reflecting Elephants', or 'The Endless Enigma', were dismissed by Breton as no more than crossword puzzles. Yet it has become commonplace for a kind of fantasy painting, on the Dalí model, to stand as the public image of a surrealist picture, while Picasso's cubist paintings (Picasso's 'Cubism' was always exempt from the strictures accorded by the Surrealists to the other Cubists) have rarely been thought of in this context.

The present exhibition reveals the mobility of

Surrealism within the field of visual art, although it does not include one important element of that activity, photography. It includes artists admired by the Surrealists, like de Chirico or Klee, or who belonged to the pre-surrealist dada phase, like Francis Picabia, as well as those who belonged to the movement. It has the extraordinary advantage, too, of including several of the paintings most significant for Surrealism: Ernst's 'Pietà' for instance, which belonged to the English surrealist painter Roland Penrose, and before him to the French surrealist poet Paul Eluard, and Picasso's 'Three Dancers', proudly and prominently reproduced in the fourth issue of *La Révolution Surréaliste* in 1925.

Surrealism demanded of its members a total commitment, and it is not surprising to find its history littered with partings and excommunications. Commitment was on the level of the whole conduct of a life, rather than in terms of a particular mode of expression within art or literature. It is clear, for instance, that there is no unity of *style* in surrealist art. In fact, the Surrealists had an ambivalent attitude towards art, and, in terms of the polarity between art and life that had traditionally structured attitudes within Paris Bohemia and the avant-garde, the Surrealists were on the side of life. They wished to dissociate themselves from the avant-garde itself, although such was the power of the ideas, and the poetry and art that Surrealism generated despite itself, during the period between the first and second World Wars, that it inevitably became the new focus of attention. But while the 19th century Bohemians lived their lives in the name of art and literature, the surrealists, in a sense, did the opposite. As Arp, the ex-Dadaist, explained in 1927, 'I exhibited along with the surrealists because their rebellious attitude toward "art" and their direct attitude toward life were as wise as dada.'

For several artists, like Arp, the fact that Surrealism was concerned with poetry and language was of specific importance. Arp was a poet as well as a plastic artist; during his dada period in Zurich he played visual and verbal games with chance, from which he developed in the 1920's a flexible biomorphic style, in paintings and wood reliefs, in which the idea of chance as part of an irrational, natural order, superior to the rational world of man, persists.

Max Ernst, who preceded Arp to Paris in 1922, wrote poems round the edges of his dada collages, and continued for a time to explore the relationship between words and images. The collages, which he sent to Paris from Germany in May 1921, for a dada exhibition, had already made him famous among the group who were to form the nucleus of Surrealism: Breton, Eluard, Aragon. Like his fellow German Dadaists, Ernst transformed the collage practice of the Cubists by sticking together, not scraps of plain or printed paper, but photographic images. Unlike Grosz and Heartfield, however, he was not concerned with social and political satire but with the free range of the imagination. Breton saw in his collages an imaginative activity that even exceeded that of a poet: 'It is the marvellous faculty of attaining two widely separate realities without departing from the realm of our experience, of bringing them together and drawing a spark from their contact ... of disorienting us in our own memory by depriving us of a frame of reference – it is this faculty which for the present sustains Dada. Can such a gift not make the man whom it fills something better than a poet ...?' These collages were to influence the paintings which immediately preceded the formation of Surrealism, like 'Celebes' and 'Pietà'. Breton's description of the effect of the collages, disorientation through the juxtaposition of different realities, was to remain the key to the surrealist image both visual and verbal.

Underpinning the surrealist experiment was an engagement with Freud, whose ideas were taken, in the first *Surrealist Manifesto* of 1924 by Breton, as of fundamental importance in their attack on narrow rationalist attitudes: 'Under the pretext of civilisation and progress, we have managed to banish from the mind everything that rightly or wrongly may be termed superstition, or fancy; forbidden is any search for truth which is not in conformance with accepted practices. It was, apparently, by pure chance that a part of our mental world which we pretended not to be concerned with any longer – and, in my opinion, by far the most important part – has been brought back to light. For this we must give thanks to the discoveries of Sigmund Freud. On the basis of these discoveries a current of opinion is finally forming by means of which the human explorer will be able to carry his investigations much further, authorised as

he will henceforth be not to confine himself solely to the most summary realities. The imagination is perhaps on the point of reasserting itself, of reclaiming its rights. If the depths of our mind contain within it strange forces capable of augmenting those on the surface, or of waging a victorious battle against them, there is every reason to seize them – first to seize them, then, if need be, to submit them to the control of our reason . . .' It is clear from the last sentence that Breton, in this passage from the first *Surrealist Manifesto* is not concerned with the curative powers of psycho-analysis, and that his model of the unconscious is a free and general one. The undertaking he describes is just as much that of poets as of the analysts themselves.

A specific aspect of Freud's ideas, loosely interpreted, formed the initial principle of surrealist exploration: the uncontrolled monologue demanded of the patient, which, Breton said, had provoked his first experiments in automatic writing, back in 1919, shortly after the end of the war. With Philippe Soupault, he had written texts which had 'the illusion of an extraordinary verve, a great deal of emotion, a considerable choice of images . . . a very special picturesque quality and, here and there, a strong comical effect.' These were published as *Les Champs Magnétiques* (Magnetic Fields) in 1919; the 1924 *Manifesto* gave the following definition of Surrealism: 'Pure psychic automatism, by which it is intended to express, either verbally, or in writing, or in any other way, the true functioning of thought. The dictation of thought, in the absence of any control exerted by reason, and outside any aesthetic or moral preoccupation.'

The source of the poetic image strong enough to create a spark that could illuminate and transform experience, could only lie, Breton held, in the unconscious. It was attainable through dreams and automatism, which should be explored, not as a means of turning away from reality, but in conjunction with it. 'I believe in the future resolution of these two states, dream and reality, which are seemingly so contradictory, into a kind of absolute reality, a *surreality*, if one may so speak.' Artists like Masson, in his automatic drawings, Ernst in his frottages, or Miró, partially, in the canvases of the mid-twenties, sought visual equivalents to automatic writing, while 8 others pursued the fixing of the 'dream' image. In

fact, no one method was chosen for the pursuit of surrealist objectives by visual means. There was some debate in the first issues of the surrealist review, *La Révolution Surréaliste*, about what the visual equivalent to surrealist writing might be. The voices in this debate, Morise and Pierre Naville, dismissed painting as too rigid and skill-dependent an activity and the idea of 'fixing' dream images as too dependent on the conscious intervention of memory. A more rudimentary kind of notation, and Masson's automatic drawing, as well as photographic experiments, were suggested, while the most radical text, by Naville, rejected any kind of visual *expression* at all, arguing in favour of experience, of the street and the cinema and the readymade image. Breton promptly put a stop to this by taking over editorial direction of the review and starting publication of a series of articles, 'Surrealism and Painting', which are less a theoretical account of what surrealist painting might or should be than an assessment of the current state of the visual arts and how they relate to Surrealism.

Certain inconsistencies in Breton's attitudes to the visual arts spring from that very tension between life and art which lies at the heart of Surrealism. On the one hand there is the impulse away from the use of a conventional medium towards freer forms of action, experience, thought – chance encounters sought in the streets of Paris, say – and on the other, a surprising loyalty towards painting. In the period during which Dada was mutating into Surrealism, Breton placed considerable trust in Marcel Duchamp, whom he saw, with Picabia, as the most vigilant mind within the evolution of the modern spirit. He admired both Duchamp's *Large Glass*, and the Readymades, which challenge the boundary between life and art (and posed a conundrum for the aestheticians which is still far from being solved). Duchamp, who persistently refused to repeat himself as an artist to the point where he apparently gave up the activity altogether (the source of Breton's only reproach to him), resisted full incorporation into the movement. He nonetheless played a crucial role in devising installations for surrealist exhibitions, such as the 1938 International Surrealist Exhibition in Paris, where 1000 sacks of coal dust were suspended from the ceiling of a darkened room, transformed into an underground cavern, or the *First Papers of*

Surrealism exhibition in New York in 1942 where a mile of string was unwound round the screens and exhibits making 'normal' viewing or movement impossible.

On the other hand, Breton could write of the unique power of the medium of paint to act as bearer of a vision: 'The need to fix visual images, whether or not these images pre-exist, the act of fixing them, has exteriorised itself from time immemorial and has led to the formation of a veritable language which does not seem to me any more artificial than spoken language . . . I owe it to myself to weigh the present state of this language in exactly the same way that I would weigh the present state of poetic language, and if necessary, to recall it to its true principles. I feel that I have the right to demand a great deal from a faculty which, more than almost all others, allows me to exercise control over the real, over what is vulgarly understood by the *real*. A few lines, a few blobs of colour, hold me in their thrall as nothing else can do . . .'

The Surrealists refused to abandon their experiment when, in 1927, a group of them including Breton joined the French Communist Party (PCF), and their autonomous activity as 'Surrealists' was questioned. This problem was accompanied by a growing division between their political and their 'private' worlds – a division Breton constantly tried to erase, even as he admitted it. 'Surrealism, which as we have seen deliberately opted for the Marxist doctrine in the realm of social problems, has no intention of minimising Freudian doctrine as it applies to the evaluation of ideas . . .' His persistence in believing that the potential liberation of consciousness should not be abandoned in favour of social action alone led to both internal and external attacks, culminating in the assault of Jean-Paul Sartre, in *Qu'est-ce que la Littérature?* (1948). Sartre clearly puts the case for the PCF: 'Breton once wrote "Transform the world, Marx said. Change life, Rimbaud said. These two orders for us are only one." This is enough to betray the bourgeois intellectual. For it is a matter of knowing which change precedes the other. For the militant marxist, there is no question that social transformation alone can permit radical modifications of feeling and of thought. If Breton thinks he can pursue his interior experiences in the margin of revolutionary activity and parallel to it, he is condemned in advance; for that comes down to saying that a liberation of the mind is conceivable in chains, at least for certain people, and, in consequence, to rendering the revolution less urgent.'

In the face of such criticism, it is all the more remarkable that Surrealism refused to abandon either pole of activity. Its refusal to narrow itself to a political field of action allowed it to remain as a radical force within intellectual life in Europe, and it proved to be a pioneer in other fields besides literature and the visual arts. It questioned, for instance, the social expediency that governed definitions of madness; it encouraged a broadening of psycho-analysis and provided a forum for new work in this field such as that of Jacques Lacan; it was also one of the first arenas in which non-Western civilisations, in particular those of Indian America, were brought into European discourse not as anthropological curiosities nor as the object of unrealisable utopian dreams, but as civilisations in their own right, whose values might challenge those tainted bastions of Western civilisations: technological progress and a narrow rationality.

A TOTAL REVOLUTION OF THE OBJECT[1]

Michael Sweeney

'Enter and contemplate with wonder the objects which civilisation has rejected . . .' wrote Herbert Read in the catalogue of the exhibition of Surrealist Objects and Poems, which opened at midnight (appropriately) on 24th November 1937 at the London Gallery. On display was a great variety of objects not usually seen in an art gallery. There were constructions made from strange combinations of objects removed from their usual context, including 'Spectre of the Gardenia' by Marcel Jean[2] (see plate 1). Here a traditional plaster head of a woman on a plinth is covered in black fabric, with zips over the eyes and a roll of film around the neck, suggesting a mysterious inner world behind the familiar external form. Other objects in the exhibition were described in the catalogue as 'Found Objects' – natural things such as a cactus, or roots, and manufactures – whose unusual form or uncertain function appealed to the finder. Of Found Objects, Marcel Jean wrote: 'Bricks, molten glass, root, pipe, star-shaped wafer, tabernacle for who-knows-what demented games, (they) reveal our multi-faceted irrational life.'[3] Also listed in the catalogue were 'Poem Objects' (mixing collage, objects and written poetry); 'Perturbed Objects' (distorted by natural forces such as fire); 'Ethnological Objects' – carvings produced by tribal cultures; 'Dream Objects'; 'Objects Produced by a Schizophrenic' and other categories, all mixed together in the display.[4] The public response to this was mainly bafflement or hostility: 'Art Show That Is Futile or Nasty' headlined the Daily Mail, for example.[5]

Behind this activity, however, was a serious vision, and the thirties was a period of intense involvement for the surrealists with finding, making and exhibiting objects. A famous example of the time is Meret Oppenheim's 'Fur Breakfast', a cup, saucer and spoon covered in thick fur, which is unnerving partly because of its unexpected sexual suggestiveness. Surrealist magazines of the period were filled with photographs of objects that intrigued them: such as that of the steam locomotive overgrown with plants, which has a peculiarly irrational atmosphere.[6] (see plate 2) All these objects seemed to the surrealists to have a fascinating, mysterious, often disturbing effect, suggesting to the imagination new realities, new beauties: that quality they called

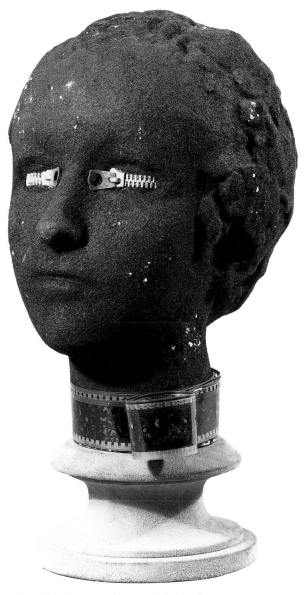

1 Marcel Jean 'Spectre of the Gardenia' 1936

'the marvellous'. André Breton proposed this as the surrealist concept of beauty: '. . . the marvellous is always beautiful, anything marvellous is beautiful, in fact nothing but the marvellous is beautiful' he decreed in characteristic tone.[7] In place of harmony or order, this beauty is strange, complex and unstable. For the Surrealists such marvellous objects represented and symbolised, in a powerfully physical form, the unconscious desires and dreams, and imaginative fantasies, which they sought to free from subservience to the rational commonplace world accepted as reality. They wished to undermine the way in which objects were looked at in terms of their rational function: Conroy Maddox wrote of 'the peculiar poetry of an object that has ceased to function'.[8] In finding and making their objects they followed their own desires, not reason, and felt they represented a fusion of the inner world of the mind and the external tangible world – into a higher reality, or 'surreality' as Breton had called it in the first *Surrealist Manifesto* in 1924.

The surrealist object could also fulfil Breton's wish that the objects seen in dreams could be made real. He had dreamed of finding a marvellous book which had pages of black wool and a spine made from a wooden statue of a gnome with a white beard, and on waking was disappointed to find that it did not exist.[9] Another strong impetus to the concentrated making of surrealist objects in the thirties was Salvador Dalí's belief that they could function symbolically for the hidden sexual desires of the unconscious, the recognition of which Surrealism insisted upon.

The Surrealists did not, therefore, regard their objects as mere curiosities, but as a means to freedom, and in a wider sense they were part of Surrealism's desire for revolutionary social transformation. Furthermore, these objects were not intended to be art, at least in any traditional sense. They were not interested in admiring them for beauty of proportion, or skill. The only important thing was the force with which they expressed the marvellous. Just as significantly, they insisted that anyone could find this, could produce objects: a rejection of the traditional idea of the artist. The chance finding of objects and new relationships between them was considered to be a creative act of the unconscious. They delighted in objects and

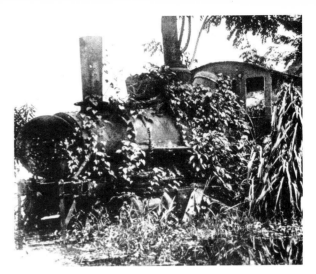

2 Locomotive in a forest, *Minotaure* No 10 3rd series 1937 p20

materials usually thought of as unworthy of attention, flea-markets being favourite places for their discovery. In their exhibitions, traditional arrangement by type or hierarchies was abandoned: all kinds of things were placed side by side. The Surrealists were fully engaged with their objects, they celebrated them . . . and celebrated too the cultures that produced the non-western objects.

There was a constant development in Surrealism's use of the object in the thirties and beyond. Their thinking was not confined to the individual object. The French Surrealists held a discussion as to how they would like to alter the great bourgeois landmarks of Paris. Breton's desire was to change the Paris Opera House 'into a fountain of perfumes' and 'rebuild the staircase with bones of prehistoric animals'.[10] Failing this kind of project, however, in their exhibitions they moved to the creation of entire environments such as at the 1938 International Surrealist Exhibition in Paris. At the entrance was a corridor lined with fantastically adorned mannikins; and Salvador Dalí's 'Rainy Taxi', a taxicab containing a seated female mannikin covered in live snails, with a water sprinkler in the roof. The main room contained a bed, brazier and numerous other objects, the floor being covered in leaves and foliage, and the ceiling hung with sacks.

Naturally many of these creations have survived only in photographs. Surrealist objects were not made for permanent display in museums and the Surrealists' involvement with objects was not con- 11

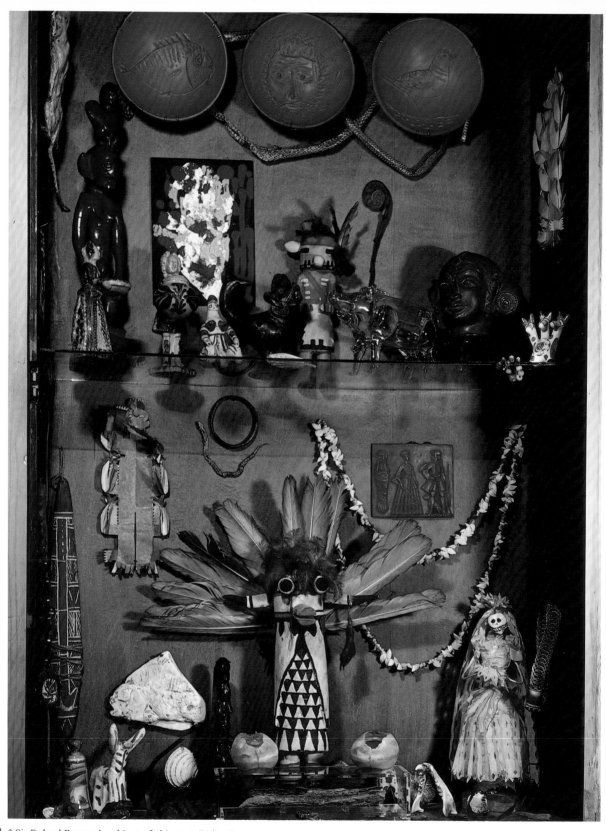

3 Sir Roland Penrose's cabinet of objects at Farley Farm

fined to their public displays, but was part of the way they tried to live their everyday lives. Many amassed personal collections of objects of all kinds. Roland Penrose, maker of elaborate surrealist objects such as 'Last Voyage of Captain Cook', 1936 and 'Gratuitous Act' 1980,[11] assembled in his later years two display cabinets full of objects he had collected (see plate 3). The range of objects seen here, and the arrangement, recall some of the 1930s exhibitions. There are tribal artefacts such as the Hopi dolls and an Aborigine bull roarer; folk art – the Mexican 'Bride of Death'; Western art – three plates designed by Picasso; decorative arts – plaques, necklaces; and a large number of found objects – stones, a sand rose, shells, snake skins, a dead rat, fossilised wood, a brittle star – many with strange forms. (Penrose also collected postcards of unusual creatures from the Natural History Museum, such as a series on Oceanic Angler Fishes.) He believed that 'the idea of the marvellous can be in everything . . . right through life'.[12] Part of the appeal of collections of objects such as this is the mixture of Surrealism and everyday living. There is no need to consider it solemnly as entirely surrealist in intention, however, (many items were added just because they appealed, or as mementoes), but it shows the extent to which, over the years, Penrose's vision continued to be permeated with Surrealism.

Such continuation is a reminder too, that surrealists have often argued that Surrealism is still relevant, and develops, even though the peak of the organised movement between the wars has passed. Looking back at the surrealist objects produced then, some now appear to be just sensationalist, or chic. The best, however, still have the power to startle, to fascinate, and to transform our ordinary perception of the world.

NOTES

1 Breton, André. 'The Crisis of the Object' 1936, in *Surrealism and Painting* (transl. S Watson Taylor, London, Macdonald, 1972).

2 In the catalogue it is entitled 'Secret of the Gardinia' (sic), but at its first exhibition in 1936 (Galerie Charles Ratton, Paris), its title was 'Le Spectre du Gardenia', the name used since.

3 Jean, Marcel. 'The Coming of Beautiful Days'. 1936. Reprinted in Jean, M. (ed.) *The Autobiography of Surrealism*. (New York, Viking, 1980).

4 The term 'Surrealist Object' was reserved in the catalogue, and other exhibitions, for the often complex constructed objects. It was also used as a general term for surrealist objects, and is used thus in this essay. The category tended to be very wide.

5 *Daily Mail*. 27.11.1937. p5. (Article by P. Jeannerat).

6 In *Minotaure* No 10 3rd series, p20. 1937.

7 Breton, André. Manifesto of Surrealism. (1924). (Transl. in Jean, M. (ed.) op. cit.

8 Maddox, Conroy. 'The Object in Surrealism'. *London Bulletin* Nos. 18–20, June 1940.

9 Breton, André. 'Introduction to a Speech on the Lack of Reality'. 1924. (In Jean, M. (ed.) op cit.).

10 Report in Jean, M. (ed.) op cit. p300.

11 Reproduced in Penrose, Roland. *Scrapbook* (London, Thames and Hudson, 1981), plate 690.

12 'Sir Roland Penrose in Conversation with Alan Young'. *PN Review*, Vol 4, No 4, 1977.

All works are in the Tate Gallery Collection unless otherwise stated. The dimensions are given in centimetres and inches, height before width, before depth.

JEAN ARP 1886–1966

Constellation selon les Lois du Hasard
Constellation according to the Laws of Chance
*c*1930
Painted wood relief
Internal measurements 45×60 ($17\frac{3}{4}$×$23\frac{5}{8}$)
Overall dimensions 55×69.7 ($21\frac{5}{8}$×$27\frac{1}{2}$)
T00242

JEAN ARP *Constellations according to the Laws of Chance* 1930

Arp worked closely with numerous artists (Miró, Breton, Tanguy and Ernst) and was associated with most major art movements in Europe between the World Wars. Yet he consistently developed his own very private language of forms through experiments with collage, reliefs, writing, poetry and sculpture. So personal was Arp's search for 'essential forms' that despite close association with the Surrealists, he could affirm that 'Surrealism supported me, but did not change me' . . . 'it perhaps emphasized the poetic, associational side of my work'.

At the time this was made, Arp seldom gave titles to his reliefs; instead he amalgamated several titles and concepts from his work in the thirties such as 'Configuration', 'Constellation' and 'According to the Laws of Chance'. Whilst Arp often made copies of his reliefs from this period, this work is probably unique. The simplicity and purposeful, 'finished' quality in Arp's relief works was usually achieved with the help of craftsmen and jig-saw machines working to a template design. His concern was that a poetic resonance should be experienced rather than a fascination for the materials used.

HANS BELLMER 1902–1975

La Poupée (The Doll) 1936/1965
Painted aluminium on brass base 46.5×26×22.5 ($18\frac{1}{4}$×$10\frac{1}{4}$×9) excluding base
height including base 64.5 ($25\frac{5}{8}$)
T01157

Bellmer abandoned his studies in engineering at the Berlin Polytechnic in 1924, having become friends with the Dadaists George Grosz and Otto Dix. He worked as a typographer, bookbinder, then industrial draughtsman. After the rise of the Nazis, he renounced all activity useful to the State and began to construct 'artificial girls'.

Bellmer's dolls grew out of his obsession with his adolescent cousin Ursula. 'I shall construct an artificial girl whose anatomy will make it possible to recreate physically the dizzy heights of passion and to do so to the extent of inventing new desires' (exhibition catalogue *Hans Bellmer* Centre National

HANS BELLMER *The Doll* 1936/65

14

d'Art Contemporain, Paris 1971–2 p.91). He began in 1933 after seeing a performance of Offenbach's *Tales of Hoffmann* (one of the characters is a doll that comes to life). In 1934 he published a book *Die Puppe* containing a series of photographs of the doll in various positions. In the December issue of *Minotaure* photographs appeared entitled 'Variations on the Assembling of an Articulated Minor'.

He then made a second doll using spherical joints which allowed him to develop beyond naturalistic representation. The new doll was shown in the *Exposition Surréaliste d'Objets* at the Galerie Charles Ratton, Paris, in 1936 and was reproduced in *Minotaure* No 8 1936 and *Cahiers d'Art* 1936.

The original is in painted wood. The Galerie A F Petit had it cast in aluminium in 1965 in an edition of eight, with one artist's copy.

La Poupée (The Doll) c1937–8
Inscribed 'A GERMAINE' and 'Avec les plus jolies (?) salutations de/Hans/Bellmer.' on left-hand sheet
Nine photographs tinted with coloured inks, eight 5.9×5.9 ($2\frac{1}{4}×2\frac{1}{4}$) and one 7.5×6 ($3×2\frac{3}{8}$) plus a sheet of pink paper 8.5×6 ($3\frac{3}{8}×2\frac{3}{8}$) with a stick on label with printed flower. Overall dimensions 21×78 ($8\frac{1}{4}×30\frac{3}{4}$)
T02305

HANS BELLMER *The Doll* 1937–8

In 1937 Bellmer made another series of photographs of dolls with the intention of publishing them in a book as he had done with photographs of his first dolls in *Die Puppe* 1934. When he fled to Paris in 1938 he took this second series with him and started preparations for their publication. The foreword which was originally written in German was translated with the help of Georges Hugnet, while the idea of hand-colouring the photographs (which had not been done in the first series) was suggested by Paul Eluard. Eluard also wrote fourteen short prose poems to accompany the photographs. However the book was not published until after the war, in 1949, when it was brought out by Heinz Berggruen in a very limited edition, as *Les Jeux de la Poupée*.

La Toupie (Peg Top) c1937–52
Oil on canvas 65×65 ($25\frac{5}{8}×25\frac{5}{8}$)
T00713

HANS BELLMER *Peg-top* c1937–52

Marcel Zerbib of the Galerie Diderot who had the artist under contract from 1955 to 1958, wrote in 1965 that 'this picture was first a project made in 1936–37 for a sculpture. This sculpture was never realised, but Bellmer continued working over this project and made several studies for it (drawings and watercolour) which became the final picture three or four years before the signature.' Bellmer signed and dated this work the day Zerbib bought it from him in 1956. The symbolism can be taken as woman turning the heads and hearts of men.

ANDRÉ BRETON 1896–1966

I saluted at six paces Commander Lefebvre des Noëttes (poem object) 1942
Inscribed 'J'AI SALUE A SIX PAS LE COMMANDANT LEFEBVRE DES NOETTES' top right,
'ET CACHET' top centre,
'JACK L'EVENTREUR' centre,
'BRAVAIT LE HIBOU TOUJOURS CLOUE' lower left,
'LA VIE' and 'ET SE REPARFUMAIT A LA TABLE MAGIQUE' across bottom.

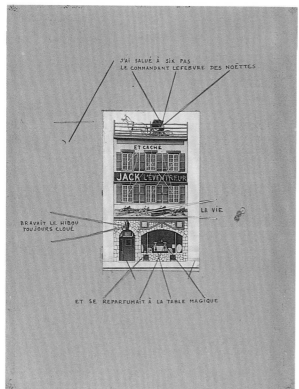

ANDRÉ BRETON *I saluted at six paces Commander Lefebvre des Noëttes (poem object)* 1942

Collage of printed colour postcard, black paper, silver paint, silk thread, silver sequins

34×25 ($13\frac{1}{2} \times 9\frac{3}{4}$)

T03807

André Breton started making poem objects in 1929 and defined the procedure as: 'Combining the resources of poetry and sculpture and in speculating on their reciprocal powers of exaltation' (José Pierre (ed.) *Dictionary of Surrealism* 1974). The phrases bear no relationship to each other or to the parts of the image they point to, but achieve a sense of mystery through the associative powers of irrational juxtapositioning. The image is a post card which Breton found in New York and gave to his wife. In the inscription on the back she wrote the word 'Trouvée' ('Found') in mid-sentence with a capital 'T', emphasising the importance of chance for Surrealism.

This poem object was sold as part of a portfolio (etchings, frottage and objects by Breton, Calder, Carrington, Chagall, Ernst, Hare, Masson, Matta, Motherwell, Seligmann and Tanguy) to raise money for the American Surrealist Magazine *VVV* edited by Hare, with Breton, Ernst and Duchamp as advisors.

16

T and Swallow c1936
Wood and wire on metal base $76 \times 32.5 \times 28.5$ ($30 \times 12\frac{3}{4} \times 11\frac{1}{4}$)

T01142

Calder who was born in Philadelphia, studied engineering, then painting at the Arts Students League 1923–6 in New York and lived in Paris between 1928–33. He exhibited in the *First Papers of Surrealism* exhibition at 451 Madison Avenue, New York in 1942 and at the last major surrealist group show *Exposition Internationale du Surréalisme* at the Galerie Maeght, Paris in 1947. His sculptures which could be moved by hand or by small electric motors were christened 'Mobiles' by Duchamp and those that did not 'Stabiles' by Arp.

'T and Swallow' was exhibited in the first exhibition in Britain almost entirely devoted to abstract painting and sculpture, organised by Mrs Nicolette Gray in Oxford in 1936 (its tour included the Liverpool School of Architecture). Calder gave this sculpture to Mrs Gray as a present. The Tate Gallery bought it from her in 1969.

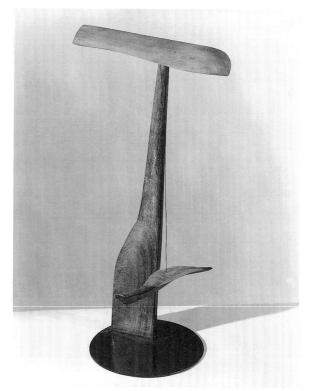

ALEXANDER CALDER *T and Swallow* 1936

The Uncertainty of the Poet 1913

Oil on canvas 105.4×94 (41$\frac{1}{2}$×37)

T04019

See reproduction on p.37

In 1906 de Chirico studied at the Munich Academy where he discovered the imaginative and fantastic imagery of Böcklin, Klinger and Kubin. He lost his interest in naturalistic painting which 'for its purpose will never be able to give me the sensation of something new, of something that, previously, I have not known' (from a manuscript published in *Giorgio de Chirico,* James Thrall Soby, New York 1955). The sense of revelation that accompanies subconscious inspiration was the purpose of painting for de Chirico: '. . . it is essential that the revelation we receive, the conception of an image which embraces a certain thing, which has no sense in itself, . . . should speak so strongly in us, evoke such agony or joy, that we feel compelled to paint, . . . ' (Giorgio de Chirico 'Mystery and Creation' 1913 in Breton, *Le Surréalisme et la Peinture* 1928 then in English in *London Bulletin* No. 6 October 1938).

The extraordinary juxtaposition of everyday objects, the combination of the antique and the modern, the exaggerated perspectives and the elongated shadows of de Chirico's metaphysical paintings which had such an impact on the Surrealists until 1919, create a mysterious atmosphere or 'Stimmung' in Nietzschean terminology. De Chirico was greatly stimulated by Nietzsche who had described his own 'foreboding that underneath this reality in which we live and have our being, another and altogether different reality lies concealed'.

The Melancholy of Departure 1916

Oil on canvas 51.8×36 (20$\frac{3}{8}$×14$\frac{3}{16}$)

T02309

In this work a painting of an imaginary map leans against a spatially and physically illogical construction of wooden elements. The play of pictorial space in this wooden 'scaffolding' against the image of the map, itself a symbol of distance and space, is disconcerting and triggers a sense of doubt in the assumed reality of the distances and distributions of land and sea plotted on the map. In disturbing the security of physical reality, the viewer is more able to

GIORGIO DE CHIRICO *The Melancholy of Departure* 1916

grasp a sense of another concealed reality, or in de Chirico's language, metaphysical reality.

The theme of travelling, with the sense of anxiety inherent in arrivals and departures, is recurrent in de Chirico's works of about 1913–16 and there are several earlier paintings of piazzas and colonnades with trains in the background (trains are possibly a reference to de Chirico's father who was an engineer for the Greek railways).

La Famille du Peintre (The Painter's Family) 1926

Oil on canvas 146.5×115 (57$\frac{5}{8}$×45$\frac{1}{4}$)

N05976

Although painted seven years after his earlier metaphysical period, de Chirico returns to the theme of mannequins which he said was inspired by a play *Les Chants de la Mi-Mort* written by his brother Andrea (who used the pseudonym Alberto Savinio), published in Apollinaire's magazine *Les Soirées de Paris* July–August 1914, about a 'man without voice, without eyes or face'. In an essay 'Sull'arte metafisica' 17

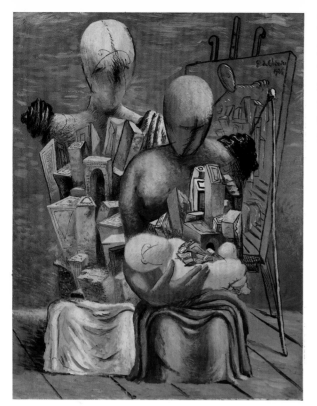

GIORGIO DE CHIRICO *The Painter's Family* 1926

of 1919 de Chirico wrote 'Every serious work of art contains two different lonelinesses. The first might be called 'plastic loneliness', that is the beatitude of contemplation produced by the ingenious construction and combination of forms, whether they be still lives come alive or figures become still . . . The second loneliness is that of lines and signals; it is a metaphysical loneliness for which no logical training exists, visually or physically.' The sense of loneliness in this painting is emphasised by the portrayal of a family group in which each figure nevertheless remains isolated.

ITHELL COLQUHOUN 1906–1988

Scylla 1938
Oil on canvas 91.4×61 (36×24)
T02140
The artist wrote of this painting (letter of 9 June 1977): 'It was suggested by what I could see of myself in a bath – this, with a change of scale due to 'alienation of sensation' became rocks and seaweed. It is thus a pictorial pun, or double-image in the Dalíesque sense – not the result of a dream but a dream-like state. 'I do like to be beside the Seaside' but have no knowledge of sailing. In early childhood I lived in the Isle of Wight and still prefer to live near the sea. I cannot see deep calm water without the impulse to immerse myself. Scylla was the name of a nymph changed first into sea monster, then into rocks on the Italian side of the Straits of Messina and reputed dangerous to mariners. When it was first

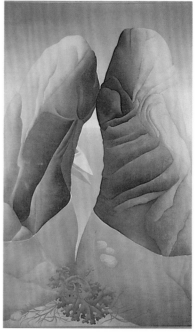

ITHELL COLQUHOUN *Scylla* 1938

shown by the London Gallery (in the Mayor Gallery's rooms) in 1939 it formed part of a sequence of seven paintings entitled *MÉDITERRANÉE*. When shown out of this sequence I have called it 'Scylla''.

SALVADOR DALI b. 1904

Autumnal Cannibalism 1936
Oil on canvas 65×65 ($25\frac{5}{8}×25\frac{5}{8}$)
Purchased from the Edward James
Foundation 1975
T01978
See reproduction on p. 38
In the early 1930s Dalí developed his 'paranoiac-critical' method which substituted for the passive conditions of self-induced hallucination favoured by the earlier surrealists, a 'paranoic advance of the mind' which would release from the unconscious

images of such force and power that they in turn would react upon it. Dalí's multiple images, organic distortions and animation of the inanimate convey the anguish induced in dreams by the constant flux and transformation of form, and his iconography draws from the sexual obsessions of the paranoid subconscious: masturbation, castration, impotence, etc. He employed a technique of photographic precision so that 'the world of the imagination, and of concrete irrationality may be as objectively evident . . . as that of the exterior world of phenomenal reality . . .' (Dalí in Julian Levy *The Conquest of the Irrational* New York 1935).

The background of this painting is the plain of Ampurdàn, the region of northern Catalonia where Dalí was born. When helping Robert Descharnes to prepare his book *Dalí de Gala*, the artist said of this work: 'These Iberian creatures, devouring each other in autumn, symbolise the pathos of civil war seen as a phenomenon of natural history,' relating the painting to the outbreak of the Spanish Civil War which he had anticipated by some months in the similar painting 'Soft Construction with Boiled Beans: Premonition of the Spanish Civil War' 1936.

Lobster Telephone 1936
Mixed media, including steel, plaster, rubber, resin and paper 17.8×33×17.8 (7×13×7)
T03257
There are at least three other versions of this object. In one the receiver is completely replaced by the lobster. This one belonged to Edward James who had acquired it from Dalí himself. Dalí has made the analogy between food and sex often in his work. In

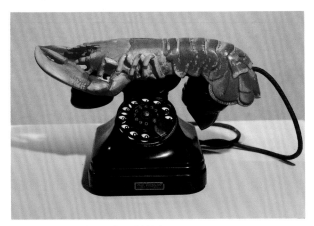

SALVADOR DALI *Lobster Telephone* 1936

1939 he created a multi-media experience entitled 'The Dream of Venus' for the New York World's Fair, part of which consisted of dressing live nude models in 'costumes' made of fresh seafood. A lobster covered the female sexual organs and similarly in 'Lobster Telephone' the crustacean's tail, where its sexual parts are located is placed directly over the mouthpiece. The analogy is also made in the painting 'The Great Masturbator' 1929.

Mountain Lake 1938
Oil on canvas 73×92 ($28\frac{3}{4}$×$36\frac{1}{4}$)
Purchased from the Edward James Foundation 1975
T01979

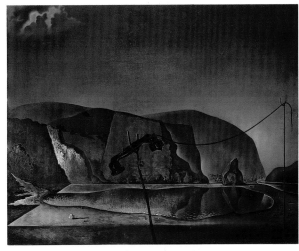

SALVADOR DALI *Mountain Lake* 1938

A Reynolds Morse (co-author with Eleanor R Morse of *The Dalí Adventure 1943–73* Cleveland, 1973) wrote in 1976 that the lake, actually no bigger than a pond, is in the Pyrenees near Requesens. 'There, after the death of Dalí's younger brother, Dalí's father took Mrs Dalí . . . Mrs Dalí was very depressed by the loss of her son, also named Salvador.

'When they finally reached the 'lake' it was so beautiful that she burst into tears, and was relieved of her depression . . . The whole picture is a moody blend of the hidden valley at Requesens and the rocks of Creus and the beach at Roasas, with of course the telephone obsession and the crutch referring to the other phone works and Chamberlain'.

It is one of a small series of paintings with telephones made in 1938–9 inspired by Chamberlain's phone calls to Hitler, which culminated in the Munich Agreement of 30 September 1938.

La Vénus Endormie (Sleeping Venus) 1944
Oil on canvas 173×199 (68×78$\frac{3}{8}$)
T00134
See reproduction on p.39
Inspired by de Chirico and a trip to Italy in 1940, Delvaux's taste for classical architecture and the classical canon of ideal beauty was confirmed. However the moonlit arcades are peopled by both clothed and naked women in a dream state of suspended animation. In a letter dated 31 May 1957 Delvaux wrote of this painting: 'It is my belief that, perhaps unconsciously, I have put into the subject of this picture a certain mysterious and intangible disquiet – the classical town, with its temples lit by the moon, with, on the right, a strange building with horses' heads which I took from the old Royal Circus at Brussels, some figures in agitation with, as contrast, this calm sleeping Venus, watched over by a black dressmaker's dummy and a skeleton. I tried in this picture for contrast and mystery. It must be added that the psychology of that moment was very exceptional, full of drama and anguish.'

He painted three earlier pictures called 'Sleeping Venus' in 1932, 1943 and 1944 and said they were inspired by the Spitzner Museum in the Brussels fair where the cashier amidst the gaiety of the fair, sat between skeletons on one side and an image of siamese twins on the other.

Leda 1948
Oil on canvas 152.7×95 (60$\frac{1}{8}$×37$\frac{3}{8}$)
T03361
The story of Leda, wife of the king of Sparta in Greek mythology, is that she was loved by Jupiter who came to her by the river in the form of a swan and lay with her. As a result of their union she laid one or perhaps two eggs – accounts vary – from which were hatched the twins Castor and Pollux from one, and Helen of Troy and Clytemnestra from the other. Traditionally the story is depicted with Leda chastely turning her head away from the swan who cranes its neck towards her face. Delvaux's Leda is not so coy and the swan not so romantically interested in her face. The eroticism of this Greek myth is made more blatant in true surrealist tradition. Delvaux painted this work for his dentist in Brussels, M. Grosfils.

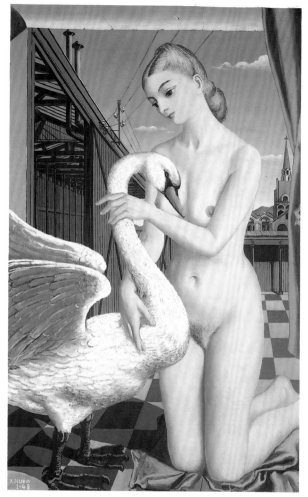

PAUL DELVAUX *Leda* 1948

PAUL ELUARD 1895–1952

A chacun sa colère (To each his anger) 1938
Collage 30×26 (76.2×66)
Private Collection
Using a method similar to the technique employed by Max Ernst, the poet Paul Eluard has created an image by juxtaposing images from several different printed sources dating from the end of the last century. The familiarity of these 19th century engravings is disturbed by the way in which certain elements are extracted and placed in new and incongruous contexts. In 'A chacun sa colère', Eluard has created a 'surreal' situation of a man reading a letter to an elephant in a bar in an effort to calm the animal's anger.

Celebes 1921
Oil on canvas 125.5×108 ($49\frac{3}{8}×42\frac{1}{2}$)
T01988
See reproduction on p.40
In Ernst's paintings of 1921–23, the Surrealists recognized a visual organisation parallel to the verbal organisation they sought in automatic writing, which seemed to come from the unconscious. Celebes was Ernst's first large picture and was bought shortly after its completion by his friend the poet Paul Eluard, who later passed it on to Sir Roland Penrose who sold it for the benefit of the Institute of Contemporary Arts in 1975. This painting, a bizarre combination of images, grew directly out of the collages Ernst had been making since 1919; no preliminary sketches were made, the painting appeared spontaneously on the canvas with few alterations as it progressed.

The images are highly ambiguous: do we see the back of the monster, the horns of its head protruding at the side, or is the head with another pair of horns at the end of the very long neck (or tail?) at the front? The boiler-like form of the body of the 'elephant' was inspired, according to Ernst, by an illustration in an English anthropological journal of a huge corn-bin of the Konkombwa tribe of the Southern Sudan.

Ernst also revealed to Sir Roland that the title 'Celebes' was taken from some scurrilous couplets popular among German schoolboys:

Der Elefant von Celebes
Hat Hinten etwas gelebes

Der Elefant von Sumatra
Der vögelt seine Grossmama

Elefant von Indien
Der kann das Loch nicht findien

(The elephant from Celebes
has sticky, yellow bottom grease

The elephant from Sumatra
always fucks his grandmamma

The elephant from India
can never find the hole ha-ha)

Pietà or Revolution by Night 1923
Oil on canvas 116×88.5 ($45\frac{3}{4}×34\frac{7}{8}$)
Prov Paul Eluard, Paris, 1923
Sir Roland Penrose, London, 1938
Gianni Agnelli, Turin, 1971
T03252
See reproduction on p.41
From 1921–1924 the images in Ernst's work show the influence of theories and case histories of Sigmund Freud, who was significant for all the surrealists. Malcolm Gee in 'Max Ernst, God, and The Revolution by Night' *Arts Magazine* March 1981, argues that Ernst based the images in this painting on Freud's study of an inverted Oedipal complex, *The Wolf Man* published in 1918, which Ernst has fused with his own childhood memories to symbolize the traumatic relationship with his father. It was painted in Paul Eluard's house with whom Ernst stayed after leaving Germany in August 1922. The Christ-figure is Ernst held by a moustached father-figure who replaces Mary. The character sketched on the wall with a bandaged head could refer to Ivan of Dostoyevsky's *The Brothers Karamazov*, or the figure may represent Guillaume Apollinaire, who was wounded during the First World War. The closed eyes could also suggest Oedipus who, in the original myth, blinds himself. Ernst has portrayed himself without expression in a trance-like state, possibly a reference to the evening sessions or *'sommeils'* held at Eluard's house when the Surrealists would attempt to release stream-of-consciousness imagery in trances induced by drugs or hypnosis.

La Ville Entière (The Entire City) 1935
Oil on paper mounted on canvas 50×61.5 ($19\frac{3}{4}×24\frac{1}{8}$)
N05289
Ernst painted a series of about a dozen paintings of this theme painted between 1935 and 1937. This one was executed whilst Ernst was a guest at Sir Roland Penrose's Chateau in the South of France.

The painting is reminiscent of Ernst's 'forest' pictures executed in his *frottage* technique of making pencil rubbings of wooden floor boards and other textured surfaces then using the resulting markings to construct the image. Ernst felt that this procedure was the true equivalent of automatic writing: 'The artist assists as a spectator, indifferent or passionate, *21*

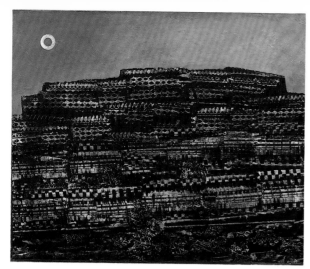

MAX ERNST *The Entire City* 1934

at the birth of his work and observes the phases of its development.' Like the 'forest' pictures, 'The Entire City', uninhabited by living creatures and dimly moonlit, evokes a feeling of alienation intensified by the lack of scale.

ALBERTO GIACOMETTI 1901–1966

Femme qui Marche (Walking Woman) 1932-3/1936
Inscribed 'Alberto Giacometti' and 'Epreuve Tate Gallery' on upper surface of base
Bronze $150 \times 27.5 \times 37.5$ ($59 \times 10\frac{7}{8} \times 14\frac{7}{8}$) including base
Presented by Alberto Giacometti and
Erica Brausen 1972
T01519
In 1922 Giacometti left Switzerland to study sculpture in Paris. In 1925 he settled there permanently. He was familiar with surrealist literature and friendly with the Surrealists by 1928, formally joining the movement in the winter of 1929–30.

Giacometti had an interest in cruelty, often in combination with sexual acts, an interest shared by the Surrealists which may have encouraged their friendship. 'Walking Woman' in its present state is not wholly surrealist except for the cruelty of its dismemberment. The elegance of its simple elongated form defies the surrealist disregard for beauty. Giacometti had previously changed the work by adding outstretched arms and a head. The left arm, pointing sideways towards the floor ended in a bunch of feathers, and the right arm, extended sideways and

upwards, ended in a flower-like hand; the head consisted of the neck and head of a cello. It was shown thus at the Galerie Pierre Colle, Paris in June 1933. Sir Roland Penrose recalls that it was sent to London, with arms but without head, for inclusion in *The International Surrealist Exhibition* at the New Burlington Galleries in 1936, but that at the very beginning of the show Giacometti decided to simplify the figure again by cutting off the arms.

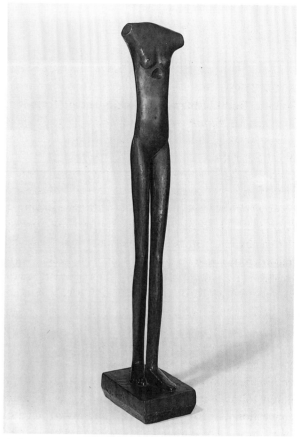

ALBERTO GIACOMETTI *Walking Woman* 1932-3/36

ADOLPH GOTTLIEB 1903–1974

The Alchemist 1945
Oil on canvas 71×91 ($28 \times 35\frac{3}{4}$)
Purchased from Adolph and Esther Gottlieb Foundation through the André Emmerich Gallery 1980
T03094
Artists in New York were aware of Surrealism through magazines and exhibitions. Gottlieb was part of the circle of American artists which included

ADOLPH GOTTLIEB *The Alchemist* 1945

Pollock, Rothko, Newman, Gorky and de Kooning. The central figure was John Graham, a Russian emigré who had lived in Paris and who knew many of the Surrealists.

For Graham art was a 'systemic confession of personality' whose purpose was 'to re-establish lost contact with the unconscious and with the primordial racial past.' His belief in a collective unconscious was shared by the Surrealists. Gottlieb felt that the unconscious could be tapped through surrealist 'pure psychic automatism': '. . . I used the process that was similar to automatic writing which was using the method of free association. And I would start by having an arbitrary division of the canvas into rough rectangular areas, and with the process of free association I would put various images and symbols within these compartments. And it was irrational . . . purely following an impulse . . . There was no direct connection one to the other . . . and a new kind of significance stemmed from this juxtaposition.' ('Adolph Gottlieb, Two Views' interview by Jeanne Siegel *Arts Magazine* February 1968).

Gottlieb thought of the Pictographs as formal assemblages of autonomous images. Of the use of his grid system he wrote: 'I am like a man with a large family and must have many rooms. The children of my imagination occupy the various compartments of my painting, each independent and occupying its own space. At the same time, they have the proper atmosphere in which to function together in harmony and as a unified group. One can say that my paintings are like a house in which each occupant has a room of his own.' (*Forty American Painters 1940–1950*

The University Gallery, University of Minnesota, Minneapolis 1951).

Gottlieb was also interested in primitivism and became a collector of African and primitive art. His interest in mysticism is evident in the titles of the works.

PAUL KLEE 1879–1940

Sie Beissen An (They're biting) 1920
Inscribed 'Klee't.r.; '1920. Sie beissen an'
on mount b. l
Watercolour over oil-colour drawing on paper
31×23.5 (12¼×9¼)
Purchased fron Frau Lily Klee 1946
N05658

Though Klee was never a member of the surrealist movement and taught at the Bauhaus at Weimar between 1920 and 1930, he was one of the few artists mentioned in André Breton's first *Surrealist Manifesto* of 1924 and was always championed by the Surrealists as a pioneer of automatic drawing. In 1925 the introduction to the catalogue of Klee's one-man

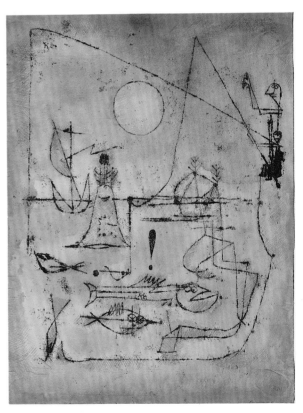

PAUL KLEE *They're Biting* 1920

show at the Galerie Vavin-Raspail was written by Louis Aragon with a poem by Paul Eluard. A month later he participated in the first surrealist exhibition.

Klee thought himself a poet and sought in his art a visual poetic metaphor for the dream, the unseen experience. He said 'I seek a distant point at the origins of creation and there I sense a kind of formula for man, animal, plant, earth, fire, water, air and all circling forces at once' (from *Diaries* 1898–1918 entry dated 1916.) His works depict signs for animals and humans and the relationships between themselves, each other, and the universe, evoked sometimes comically, sometimes more disturbingly.

He allowed his hand to flow automatically: 'My hand is simply a tool remotely controlled. It is not my head that is functioning but something else, something higher and more remote, somewhere' (*Paul Klee, Dokumente und Bilder aus dem Jahren 1896–1930*, Bern, 1949, letter to his wife in 1918).

Komödie (Comedy) 1921
Inscribed "Klee" bottom right: "1921/108 Komödie" on mount: "privatebes, sg.k." and "28" on second mount.
Watercolour over oil-colour drawing on paper 30.5×45.5 ($12 \times 17\frac{7}{8}$)
Purchased from Frau Lily Klee 1946
N05657
Though he allowed his subconscious to inspire the initial stage of his drawings, Klee was also pre-occupied with theories of colour and structure, the former due particularly to the influence of Delaunay, the latter by Cubism, and he felt strongly that automatism was a means to an end and not an end in itself.

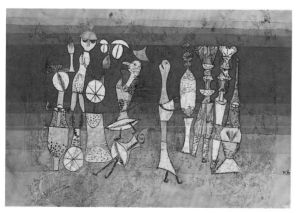

PAUL KLEE *Comedy* 1921

The freely drawn characters in 'Comedy' are set on a more rigorously structured background of colour-graduated horizontal planes recalling Delaunay. According to Will Grohmann in *Paul Klee* (Paris, 1929), 'Comedy' stems from the parties and little theatrical performances; a regular feature of student life at the Bauhaus in which Klee took great delight.

Abenteuer eines Fräuleins
(A Young Lady's Adventure) 1922
Inscribed 'Klee'b.l.; also '1922/152' on mount b.l. and Abenteuer eines Fräuleins' b.r.
Watercolour on paper 43.5×32 ($17\frac{1}{4} \times 12\frac{5}{8}$)
Purchased from Frau Lily Klee 1946
N05659

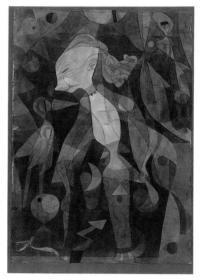

PAUL KLEE *A Young Lady's Adventure* 1922

Will Grohmann commented on this work (letter of 14 June 1953): 'Klee had a very distant relation to women and saw in general their comic side. This mannequin-like female figure must represent a fashionable lady, who in spite of her striking elegance is more or less helpless in face of the oppressive spirits. The evil bird takes hold of her, while the arrow threatens to attack. It is probably also a 'Temptation'. It is amusing to recall that this watercolour was known at the Bauhaus as 'The English Miss'.' In his book *Paul Klee and the Bauhaus* (Bath, 1973) Christian Geelhaar has emphasised its erotic aspects, and has drawn attention to the signifiance of the arrow in various of Klee's works as a phallic symbol.

Eye, Nose and Cheek 1939
Hoptonwood stone 89×87×28.5
$(35×34\frac{1}{2}×11\frac{1}{4})$
T00871

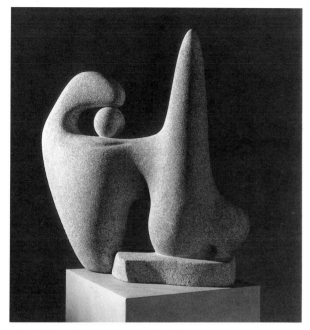

F E MCWILLIAM *Eye, Nose and Cheek* 1939

In 1938 McWilliam was one of the British artists described as surrealist included in the *Exhibition of Living Art* at the London Gallery in Cork Street directed by E L T Mesens, the Belgian surrealist and friend of Magritte. He also exhibited in *Surrealism Today* at the Zwemmer Gallery in 1940.

He studied drawing at the Slade School from 1928–31 and then worked in Paris until 1932 during one of Surrealism's most active periods. He began sculpting in 1933. This piece (which was not exhibited until 1966) was one of a series of carvings called 'The Complete Fragment' of which 'Profile' 1940, also in the Tate's collection, was the last. In a letter to the compiler of the entry on this last sculpture, McWilliam wrote (24 June 1963) 'These carvings were mostly part or parts of the head, greatly magnified and complete in themselves. They concern the play of solid and void, the solid element being the sculpture itself while the 'missing' part inhabits the space around the sculpture.' (*Tate Gallery Catalogue, Modern British Paintings, Drawings and Sculpture* Vol II, 1964).

Passage de l'Opéra 1940
Oil on canvas 137.2×94 (54×37)
T03052

The Passage de l'Opéra, one of the old arcades of Paris, was the subject of a long essay evoking its poetry and mystery by the surrealist writer Louis Aragon written in 1924, published 1926 in *Le Paysan de Paris*. It became a place of special significance for all the Surrealist group. In a letter (Tate Gallery Archive 7510.13) Maddox wrote: 'Aragon points out that his wanderings around the Passage de l'Opéra were without purpose, yet he waited for something to happen, something strange or abnormal so as to permit him a glimpse of a 'new order of things'.' This evocation of mystery appealed to the Surrealists. The passage was also renowned as a meeting place among prostitutes and its lack of respectability was another source of appeal.

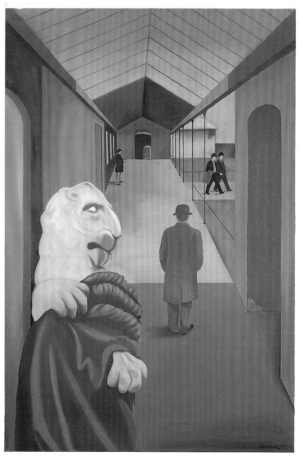

CONROY MADDOX *Passage de l'Opéra* 1940

Le Dormeur Téméraire (The Reckless Sleeper) 1927
Oil on canvas 116×81 (45½×32)
TO1122

See reproduction on p.42

Magritte was profoundly struck by the first de Chirico painting he saw in 1922; his first one-man show in Brussels in 1927 brought him into contact with the Belgian surrealists led by Paul Nougé, and in that Summer he moved to a suburb of Paris and became associated with the French surrealists. Breton claimed that 'from that time on, he was a main prop of Surrealism'. He returned to Brussels in 1931 after spending a year in England.

Magritte was concerned in revealing the affinities and relations between conventional commonplace elements by means of displacements, juxtapositions, fusions and disparities of scale; his technique and style are straightforward since he felt that painterly devices and distortion distract from the 'poetic purity' of the image. His objects are totally prosaic. Magritte argued that the maximum effect of the displacement of objects could only occur when the objects themselves were familiar. '. . . a child on fire will surely move us more than a distant planet burning itself out'. (Lecture, 1939).

But his imagery is not randomly chosen: 'There is a secret affinity between certain images; it is equally valid for the objects which those images represent . . . We are familiar with birds in cages; interest is awakened more readily if the bird is replaced by a fish or a shoe; but though these images are strange they are unhappily accidental, arbitrary. It is possible to obtain a new image which will stand up to examination through having something final, something right, about it: it's the image showing an egg in the cage.' (Lecture 1937 published in Louis Scutenaire *René Magritte* Brussels, Librairie Sélection 1947).

In 'The Reckless Sleeper' a bowler hat, a candle (with Freudian associations), an apple, a bird and a mirror are embedded in a soft tablet as though hovering in the subconscious mind of the sleeping man who lies in a coffin-like box, whose ascent into the dark sky is stopped by the limits of the canvas. The objects are extremely familiar, there is no 'action' taking place, but Magritte has created a picture whose mood is one of disquiet, almost fear.

L'Homme au Journal (Man with a Newspaper) 1928
Oil on canvas 115.5×81 (45½×32)
T00680

In a letter to André Bosmans of 6 December 1960 Magritte said that the image of a man seated in a room was based on an illustration in *The Natural Method of Healing* by F E Bilz, a popular 'new and complete guide to health' published in 1898. Margritte followed the main lines of the composition, but eliminated a number of details and simplified the forms.

The repetition of the same image in four compartments (almost identical except for the presence of the seated man) is itself unusual in Magritte's work. In a letter dated 31 July 1965 he wrote ''Man with a Newspaper'. . . like my other paintings, is concerned with the description of thought combining forms (visual) drawn from the tangible world – but in a way that mystery is evoked . . . I regard the description of inspired thought as poetry'.

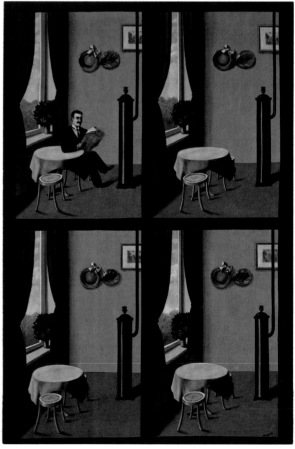

RENÉ MAGRITTE *Man with Newspaper* 1928

Annunciation 1930
Oil on canvas 113.7×145.9 (44¾×57)
T04367
The titles of Magritte's paintings were given by him, or sometimes, according to Paul Nougé, by his friends, after they were finished. 'The titles of my paintings accompany them in the same way that names correspond to objects, without illustrating them or explaining them.' (William Rubin *Surrealist Art* Thames and Hudson 1968 p.205). The ambiguous scale in this 'landscape' recalls Ernst's 'forests' and 'cities'.

RENÉ MAGRITTE *Annunciation* 1930

The Future of Statues c1937
Oil on plaster relief 33×16.5×20 (13×6½×8)
T03258
The artist's wife, Georgette, sent a plaster cast to Magritte while he was staying in the home of Edward James in Wimpole Street, London, as Magritte wanted to offer it to him as a present. In 1939 Norman Parkinson photographed Edward James in profile with eyes closed juxtaposed with this work, then in his possession *(Norman Parkinson: Fifty Years of Portraits and Fashion* National Portrait Gallery 1981). Plaster reproductions of Napoleon's death-mask were stocked by Maison Berger, the artists' materials shop belonging to Georgette Magritte's sister, Léontyne Hoyez Berger. Magritte is known to have painted five of these casts with sky and clouds, at least four of which are extant.

Hung high above eye level, the bizarre quality of this work is enhanced by the element of surprise.

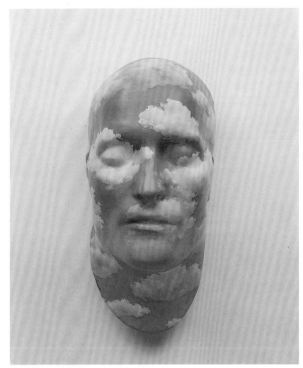

RENÉ MAGRITTE *The Future of Statues* c1937

MAN RAY 1890–1976

Cadeau/objet (Gift/object) 1921
Flat iron with nails
Private Collection
Man Ray arrived in Paris from New York in 1921. He had already constructed a number of dada 'Readymades'. Unlike Duchamp's, Man Ray's 'Readymades' are 'assisted', in this case by the

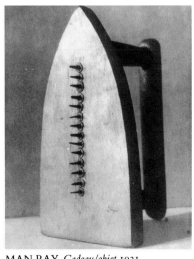

MAN RAY *Cadeau/objet* 1921

application of tacks onto the base of the iron. Readymades were the epitomy of dada 'anti-art' in that they were industrially made objects merely selected by the artist who had, by giving them a title, rendered them 'art objects', or more accurately anti-art objects by the lack of artistic creativity. The tacks on the iron evoke a sense of cruelty, particularly as in everyday use a great amount of pressure is applied to an iron when flat. This 'tampering' with the mundane would have been particularly appealing to the Surrealists.

According to May Ray 'Cadeau' was made during his first exhibition in Paris at the Librairie Six in December 1921 for Erik Satie.

JOAN MIRÓ 1893–1983

Maternité (Maternity) 1924
Oil on canvas 91×74 ($35\frac{3}{4}×29\frac{1}{8}$)
Private Collection
Through André Masson whose studio was adjacent, Miró met all the leading French poets and became obsessed with poetry: 'I gorged myself on it all night long'. 'What really counts is to strip the soul naked. Painting or poetry is made as we make love; a total embrace, prudence thrown to the wind, nothing held back . . . ' (James Johnson Sweeney *Joan Miró* Museum of Modern Art New York 1941.)

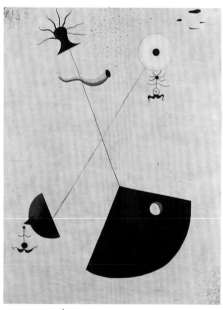

JOAN MIRÓ *Maternité* 1924

Miró's organic forms appear at first totally abstract and his imagery was created often from a state of hallucination (induced by hunger during Miró's impoverished early days in Paris) in the surrealist automatist tradition. However he said: 'Forms take reality for me as I work, in other words, rather than setting out to paint something, I begin painting and as I paint the picture begins to assert itself, or suggest itself under my brush. The form becomes a sign for a woman or a bird as I paint. The first stage is free unconscious, . . . The second stage, however is carefully calculated.' ('Joan Miró: Comment and Interview' James Johnson Sweeney *Partisan Review* February 1948.)

Both the calculated and the poetic aspects of his painting are evident in 'Maternité' where the body of a woman is simplified to two crossed lines, unbalanced like a pair of scales on the left by the boy, while the girl swings in the air on a moon-breast on the right. They seem delicately poised as though on a see-saw pivoting on the woman/mother figure.

Peinture (Painting) 1927
Water-soluble background and motifs on canvas 97×130 ($38\frac{1}{2}×51\frac{1}{2}$)
T01318
See reproduction on p.43
Due to his love of poetry, Miró was very familiar with surrealist literature and Margit Rowell suggests that this painting's source may have been Apollinaire's *Les Mamelles de Tirésias*, first performed in June 1917 which Apollinaire termed a 'drame surréaliste'. However the white shape on the left was identified by Miró in December 1977 (information from Sir Roland Penrose) as a horse and the picture may also relate to the series of paintings of circus themes from 1917.

A Star Caresses the Breast of a Negress
(Painting Poem) 1938
Oil on canvas 129.5×194.3 ($51×76\frac{1}{2}$)
T03690
See reproduction on p.44
The surrealists used words and images together to 'combine the resources of poetry and plasticity and speculate on their power of reciprocal exaltation.' (Breton, *Le Surréalisme et la Peinture*). The words might sometimes fuse with the forms to which they

refer or the rhythm and lines of the words themselves may inspire the image. Here the shape of the letters 'resse' in the rhyming words 'caresse' and 'negresse' may have prompted the form at the bottom of the canvas which is lightly touched by the spindly 'hand', itself attached to a simplified yet comical 'head'.

Femmes, Oiseau au Clair de Lune (Women and Bird in the Moonlight) 1949
Oil on canvas 81.5×66 (32×26)
N06007

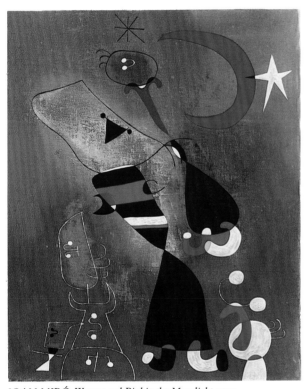

JOAN MIRÓ *Women and Bird in the Moonlight* 1949

Jacques Dupin in *Joan Miró: Life and Work* London 1962 has pointed out that Miró's paintings of the period 1949–50 can be divided into two contrasting and complementary series: a series of very elaborate paintings noteworthy for the diversity and extraordinary refinement of their grounds (the present work is an example of this) and a further series of completely spontaneous paintings of a summary, gestural character. In the 'elaborate' paintings, he writes, 'Figures, birds, animals, stars, and signs play and combine with one another with an elegance and acrobatic sureness, a casualness in the revelation of

mystery and a joy in their nostalgic evocation of a primitive world which together confound the imagination.'

HENRY MOORE OM, CH 1898–1986

Four-Piece Composition: Reclining Figure 1934
Alabaster and marble base 17.5×45.7×20.3 ($6\frac{7}{8}$×18×8)
T02054

This carving exemplifies Moore's powerfully expressive fusion of the contrasting surrealist and abstract impulses of the 1930's, and of organic with formal qualities. Though disturbing on one level, the radical dismemberment of the body's parts serves actually to reinforce the central theme of all Moore's work; the complete human figure, and our awareness of interrelated and interdependent forms in space.

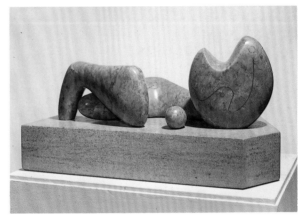

HENRY MOORE *Four Piece Composition: Reclining Figure* 1934

'Four-Piece Composition' is carved in an indigenous English material. Moore's treatment enhances our sense of nature's processes and forms, while the graphic incisions, inspired by 'primitive' art, emphasise the surface of the alabaster. The specially designed deep base helps to articulate the relationship between the sculpture's forms and the surface on which they rest.

Three Points 1939–40
Bronze 14×19×9.5 ($5\frac{1}{2}$×$7\frac{1}{2}$×$3\frac{3}{4}$)
T02269
The work exists in three different materials; lead, cast-iron and bronze. The Tate's bronze is one of two cast from the original.

29

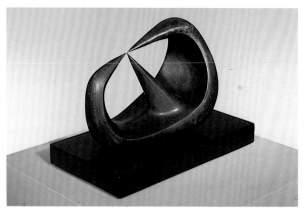

HENRY MOORE *Three Points* 1939–40

Theories as to the source of inspiration for this work abound. In the Tate's *Henry Moore* exhibition catalogue of 1968, David Sylvester suggested the famous School of Fontainebleau double portrait of Gabrielle d'Estrées' nipple being pinched as a point of reference for 'Three Points'. Others have seen the influence of Surrealism more forcefully in this work, with it's spiky, aggressive and perhaps phallic connotations.

Moore acknowledged that by 1938–9 he was very conscious of the pervasive spirit of Surrealism but said that 'it was a mistake to try to track down a single source for 'Three Points''.

PAUL NASH 1889–1946

Harbour and Room 1932–6
Oil on canvas 91.4×71.1 (36×28)
T03206

This painting was exhibited in the *International Surrealist Exhibition* at the New Burlington Galleries, London, 1936. However, Nash made studies for it in 1930 and 1931 following a stay in Toulon at the Hotel du Port in 1930. The hotel overlooked the harbour. Margaret Nash was later to describe how in 'Harbour and Room' Nash was to make use of a visual illusion, 'a French Man O'War sailing into our bedroom; the idea resulting from the reflection of one of the ships in the very large mirror which hung in front of our bed'.

The distorted perspectives of the painting and architectural features in the bottom right of the canvas recall de Chirico whose exhibition in London in 1928 had been a great influence on Nash.

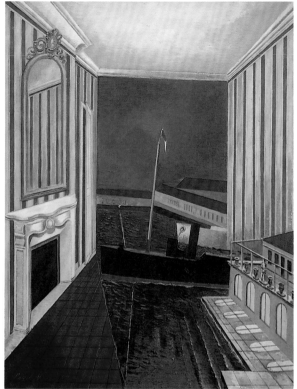

PAUL NASH *Harbour and Room* 1932–6

Landscape from a Dream 1936–38
Oil on canvas 68×101.5 (26¾×40)
N05667

Although he had exhibited with the surrealists at the New Burlington Galleries in 1936, Nash was never totally associated with them. In a letter of 1942 to Herbert Read he wrote, 'I did not find Surrealism, Surrealism found me.' But though the symbolism and enigmatic quality of de Chirico's paintings, and Ernst's primeval ruined cities and overgrown forests

PAUL NASH *Landscape from a Dream* 1936–8

undoubtedly influenced his direction, he never tampered with the surrealist notions of automatism because he would not 'allow the promptings of the unconscious to lead me beyond a point of defensive control'.

SIR ROLAND PENROSE 1900–1984

The Last Voyage of Captain Cook 1936/67
Oil on wood, plaster and steel 69.2×66×82.5 (27¼×26×33½)
T03377
'Captain Cook's Last Voyage' was first shown at the *International Surrealist Exhibition* in 1936 which Penrose had helped organise. André Breton was photographed next to it when he delivered his

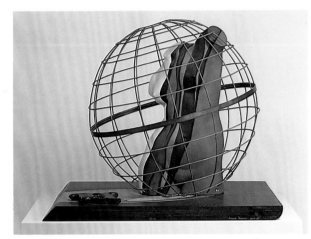

SIR ROLAND PENROSE *Last Voyage of Captain Cook* 1936

opening speech to the exhibition. The work incorporates a set of quite ordinary objects put together to achieve what Penrose sees as a poetic effect. The classical plaster model was a decorative object sold in the shops around Montmartre in Paris which Penrose had bought while living there. He had the metal globe made by a bicycle repairer in London and the saw came from his own workshop. This is a second version of the work reconstructed from memory with the aid of photographs by the artist and his son in 1967, as the first version was destroyed during the Second World War. The base of the original version has since been found and is at present undergoing conservation.

Penrose gave the work the deliberately 'surrealistic' title for the *International Surrealist Exhibition*.

Magnetic Moths 1938
Collage (pencil and water colour on cardboard)
81.3×55.8 (32×22)
T02021
'Magnetic Moths' is one of a series of collages that the artist made from 1936 onwards. All use a series of brightly coloured picture postcards, usually of Mediterranean scenes unlike those in 'Magnetic Moths'

SIR ROLAND PENROSE *Magnetic Moths* 1938

which are all Parisian. Penrose was first attracted to these garish postcards in 1936 while staying in Mougins in the South of France with Picasso, Man Ray, Eluard and others. He found that by arranging them in a series of repeated images he had created a new language whereby pattern and colour became independent of the pictorial meaning of each card.

Moths, with their power of metamorphosis, were of special interest to the Surrealists, and provide a fitting subject for Penrose's collage technique. The moth is attracted to a flame strategically placed behind postcard images of the Paris Opéra. As the Opéra was a favourite haunt of the Surrealists, the collage therefore embodies something of the Surrealists' lives and their preoccupations.

Le Grand Jour 1938
Oil on canvas 76×101 (30×39¾)
T00671
Penrose wrote in a letter of 21 August 1964:
"Le Grand Jour' is a collage painting although nothing but paint has been applied to the canvas. The images are unrelated to each other but by coming together like images in dreams they produce new associations which can be interpreted in whatever way the spectator may feel inclined. The title 'Le *31*

Grand Jour' was invented when the painting was nearly finished. It was suggested by the images which had already found their places on the canvas and which seemed to indicate an atmosphere of

SIR ROLAND PENROSE
Le Grand Jour 1938

excitement and exhileration centred round the distillation of a dance hall and a sunset in an alembic.' (An alembic, in the centre of the composition, is a vessel used in distilling.) He suggests then that the picture came to life almost in the manner of automatic writing; a spilling over of his unconscious.

Portrait 1939
Oil on canvas 30×25 (760×640)
T03400
See reproduction on p.45
The illogical phrases in this painting embody the automatist practice of combining words free from the constraints of rational consciousness. The repetition of say, 'his hair air', also shows that Penrose may have been attracted by the actual form of the words, which in this case is echoed in the moustache-like shape at the top of the painting.

FRANCIS PICABIA 1879–1953

Conversation I 1922
Watercolour and pencil on card 59.5×72.4 ($23\frac{3}{8}×28\frac{1}{2}$)
T00305
Though a pioneer of New York, Barcelona and Paris Dada, Picabia was, in Maurice Nadeau's words, a 'para-Surrealist' because he resented Breton's dogmatism and was reluctant to become totally adherent to Surrealism. Picabia's extreme originality however made him a great influence on the movement.

'Conversation' is one of a small group of water-colours and oils with colour-striped female nudes or

FRANCES PICABIA *Conversation I* 1922

abstract shapes superimposed on a black-and-white striped background. William A. Camfield wrote in the catalogue of the Guggenheim Museum's Picabia exhibition 1970: 'Picabia's intentions remain mysterious, but in the headless, limbless figures entitled 'Conversation' it is possible to note a taste for ironic contrast which extends to the formal properties of the painting – optical tensions between two and three dimensional space and contrasts of forms that are organic and abstract, soft and hard, static and moving, positive and negative.' The 'conversation' alluded to in the title may be the dialogue between these contrasting elements.

PABLO PICASSO 1881–1973

Les Trois Danseuses (Three Dancers) 1925
Oil on canvas 215×142 ($84\frac{3}{4}×56$)
T00729
See reproduction on p.46
This painting marks the turning point from Picasso's classical style to a new period of emotional violence and expressionist distortion, which together with the sexual aggression caught the attention and praise of the Surrealists who reproduced it in *La Révolution Surréaliste* No. 4 15 July 1925 as 'Jeunes Filles dansant devant une Fenêtre'.

Each of the dancers is treated in a different way. The central figure is much the least distorted and in the space between its upstretched arm and the figure on the right is a profile which can either be read as the shadow of a fourth figure, or as a part of the angular

dancer on the right.

The dancer on the left is unmistakably female. She dances with a much more frenzied action than the others, her head and torso thrown back. One of her breasts is seen from the front surrounded by a black shape that makes it look like an eye, whilst the other breast is shown in profile and in shadow. Picasso emphasises her sex by the ambiguous patch of sky and railings visible through her skirt.

The influence of primitive and African sculpture is obvious. The head incorporates another profile head like a crescent moon on the left which, in total contrast to the savage frontal view, is gentle and dreamy, even pretty.

Picasso told Sir Roland Penrose in January 1965, just before the picture was dispatched to London, that 'While I was painting this picture an old friend of mine, Ramon Pichot, died and I have always felt that it should be called 'Death of Pichot' rather than 'The Three Dancers'. The tall black figure behind the dancer on the right is the presence of Pichot'. Pichot was a Spanish painter and a great friend of Picasso; he and his wife Germaine had spent their holidays together in 1910. The friendship ended when Picasso abruptly left his current mistress who was a close friend of the Pichots.

Germaine Pichot plays an important role. Picasso had a great friend, Carlos Casagemas, a Catalan painter. When he and Picasso first arrived in Paris they had been given Germaine's name by friends in Spain. She was young and very pretty and Casagemas became obsessed with her; his love was not reciprocated and he suffered from deep depression and thought only of suicide. In 1901 he fired a revolver at Germaine but missed, then shot himself in the head. Picasso was deeply upset and painted several pictures that year commemorating Casagemas's death.

The crescent shaped profile of the left hand figure resembles the portrait of Germaine in Picasso's 'At the Lapin Agile' of 1905 and we can fairly assume that this figure is a counterbalance to her husband on the right of the painting.

If the left hand figure is Germaine and the right hand figure Ramon Pichot, then the central figure can be interpreted as Casagemas and the dark rings around the eyes and slightly receding chin bear a resemblance to him.

Weeping Woman 1937
Oil on canvas 59.7×48.9 (23×19)
TO5010

Accepted by H.M. Government in lieu of Inheritance Taxes, with additional payment (Grant-in-Aid) and assistance from the National Heritage Memorial Fund, National Art-Collections Fund and Friends of the Tate Gallery 1987.

This painting was purchased from the artist as soon as it had been painted, by Sir Roland Penrose, friend and biographer of Picasso. It was passed to his son who lent it to the Tate before it became part of the Tate's permanent collection.

'Weeping Woman' post-dates Picasso's most celebrated work 'Guernica' by four months and develops the central theme of the mural; woman as the anguished victim of war. 'Guernica', a horrific image of the destruction of human beings was inspired by the tragedy of the German bombing of the Basque capital town, Guernica in April 1937, at an hour when its streets were thronged with people. The emotional intensity of 'Weeping Woman' is made even more extreme by confining all the distress to a woman's head. The psychological impact of the work renders it surrealist.

PABLO PICASSO *Weeping Woman* 1937

Birth 1938–41
Oil on canvas 116.4×55.1 ($45\frac{3}{4}$×$21\frac{3}{4}$)
T03979

Pollock was a member of the circle of young American painters including Gottlieb familar with Surrealism. Pollock was concerned in his early work with myth, ritual and sexuality, but it was the surrealist desire to repress all rational control which most stimulated him. He wrote. . . 'the fact that good European moderns are now here is very important,

JACKSON POLLOCK *Birth* 1938–41

for they bring with them an understanding of the problems of modern painting. I am particularly impressed with their concept of the source of art being the Unconscious. This idea interests me more than the specific painters do, for the two artists I admire most, Picasso and Miró, are still abroad. . .' (*Arts and Architecture* LXI February 1944). He was invited to exhibit with the Surrealists at the *International Surrealist Exhibition* in New York in 1942.

Dehors 1929
Oil on canvas 116×88.5 ($45\frac{3}{4}$×$34\frac{7}{8}$)
Private Collection

An autodidact, Tanguy had seen a de Chirico in Paul Guillaume's gallery in 1923 and decided to be a painter. He joined the Surrealists in 1925. By 1927 he had developed a precise and illusionistic style, with a smooth surface texture to create atmospherically ambiguous scenes which might be the sea bed, or a desert, populated by biomorphic abstract figures. In the preface to the catalogue of Tanguy's exhibition in 1927 at the Galerie Surréaliste, Breton wrote: 'What do we find in this domain of pure form towards which any meditation upon painting will surely guide us, here where a ball of feathers weighs as much as a ball of lead, where all living things can fly and burrow with equal ease, where the most hostile elements meet and confront each other without catastrophic results, where we know that a youthful mind will remain for ever youthful, where fire readily kindles on water?' (text reproduced in Breton's *Le Surréalisme et la Peinture* 1928).

YVES TANGUY *Dehors* 1927

LIST OF SHOWCASE EXHIBITS

Documents and Periodicals

Some of these items will not be in the exhibition until October 1988 as they are on loan to the Scottish National Gallery of Modern Art in Edinburgh.

1 *391*
Editor Francis Picabia
Barcelona, New York, Zurich, Paris
January 1917 – October 1924
Numbers 12, 14, 19
Private Collection

2 *Littérature*
Editors Louis Aragon, André Breton, Philippe Soupault
Paris
New Series March 1922–June 1924
Numbers 5, 8
Private Collection

3 *La Révolution Surréaliste*
Paris
December 1924–December 1929
Numbers 1, 4, 6, 7, 12
Private Collection

4 *Documents*
Editor Georges Bataille
Paris
1st series Numbers 3, 5, 6
2nd Series Number 1 1929–30
Tate Gallery Library

5 *Le Surréalisme au Service de la Révolution*
Editor André Breton
Paris
July 1930–May 1933
Numbers 1, 5
Private Collection

6 *International Surrealist Bulletin*
Issued by the Surrealist Group in England
London. no. 4, September 1936
Private Collection

7 *Minotaure*
Revue artistique et littéraire
Paris, Albert Skira

February 1933–February 1939
Numbers 2, 7, 12–13
Private Collection

8 *London Bulletin*
Editor E L T Mesens
London: London Gallery Ltd 1938–40
Numbers 6, 8–9, 14, 15–16
Private Collection

9 *VVV*
Poetry, plastic arts, sociology, psychology
Editor: David Hare Editorial advisers:
André Breton, Max Ernst, Marcel Duchamp
New York June 1942–February 1944
Numbers 1, 2–3
Private Collection

10 *View*
New York September 1940–March 1947
Series 5 Number 1
Private Collection

11 *Exposition Surréaliste d'Objets*
Catalogue of an exhibition at the
Galerie Charles Ratton 1936
Private Collection

12 *International Surrealist Exhibition*
Catalogue of an exhibition at the
New Burlington Galleries 1936
Private Collection

Chosen Objects

1 *Kachina doll*
Arizona, Hopi Indian
Painted wood and feathers 46.5×46
Private Collection

2 *Venus of Lespugue*
Cast from French Prehistoric figure
Plaster and paint 14.6×6×3.8
Private Collection

3 *Sand Rose*
Silica 10×8
Private Collection

4 *Figure*
Philippines
Wood 41×8.7×7.5
Private Collection

5 *Xinlet: Majorcan whistle*
Clay and paint 14×7×10
Private Collection

6 *Model totem*
Haida, Queen Charlotte Islands
Argillite 23.2×6.7×5.2
Private Collection

7 *Figure*
Pompeii
Bronze 16×4.5
Private Collection

8 *Tree*
Spain
Aluminium and paper 28×17
Private Collection

9 *L'art chez les fous. Le dessin, la prose, la poésie*
Marcel Réja, Mercure de France Paris 1908
Lionel Burman

The following are all lent by the Liverpool
Museum, National Museums and Galleries
on Merseyside

10 *Crested mask*, Northern New Ireland
wood, barkcloth, shell, fibre and seeds
46×16×44

11 *Pre-Columbian Moche vessel* in the form of a bird
with a drum, Peru
clay 21×13×12

12 *Pre-Columbian Nazca vase*, Peru
clay and paint 10×11 in diameter

13 *Codex Fejervary Mayer*; card facsimile of Mexican
picture manuscript, the original made of deer skin
with gesso 17.5×17.5

14 *Maori Tiki pendant*, New Zealand
jade or nephrite 11×7

15 *Mask*, Sepik River, New Guinea
basketwork and paint
22×26×9

16 *Bird figures*, Sepik River, New Guinea
painted wood 46×8

17 *Dogan Mask*, Mali, Africa
painted wood 64×18

18 *Mask*, described variously as Kwakiutl, Haida or
Tlingit, North West Coast, America
painted wood 23×22×15

19 *Haida pipe*, North West Coast, America
argillite 30×9×1

20 *Haida totem pole*, North West Coast, America
argillite 48×8×7

21 *Postcard of Kachina Dolls*, South West America
sent to Nancy Cunard by 'JF'
printed card 14×9

22 *Zapotec funerary urn*, Mexico
earthenware 40×25×18

23 *Chi wara antelope mask*
Republic of Mali, Bambara people
wood tied with string onto basketry cap 56×60

24 *Plaster model of the surface*
$Z = 3a (X^2 - Y^2) - (X^3 + Y^3)$ 1910
Science Museum, London

25 *Wooden model demonstrating*
Julius Plücker's Quartic surfaces 1876
Science Museum, London

26 *Jack in the Pulpit vase* 1913
Inscribed L C Tiffany Favrile on base
Transparent amber glass covered with gold
and blue irridescent 48.2 high
Haworth Art Gallery, Accrington

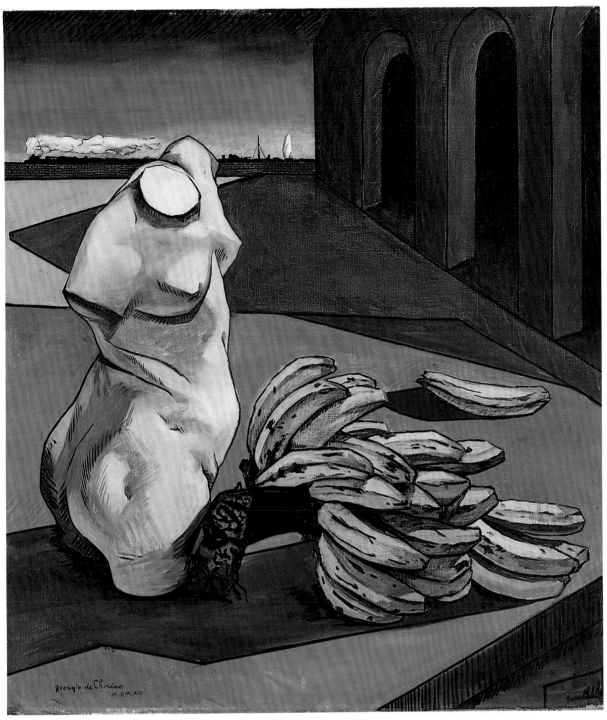

Giorgio de Chirico 1888–1978
The Uncertainty of the Poet 1913

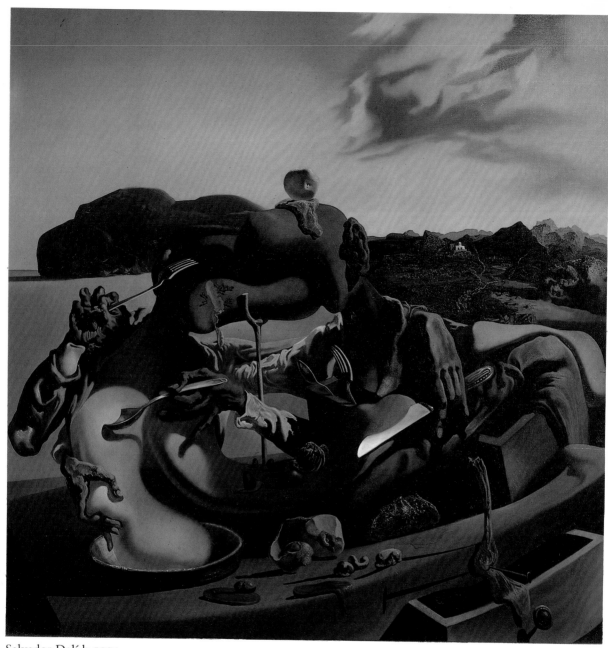

Salvador Dalí b. 1904
Autumnal Cannibalism 1936

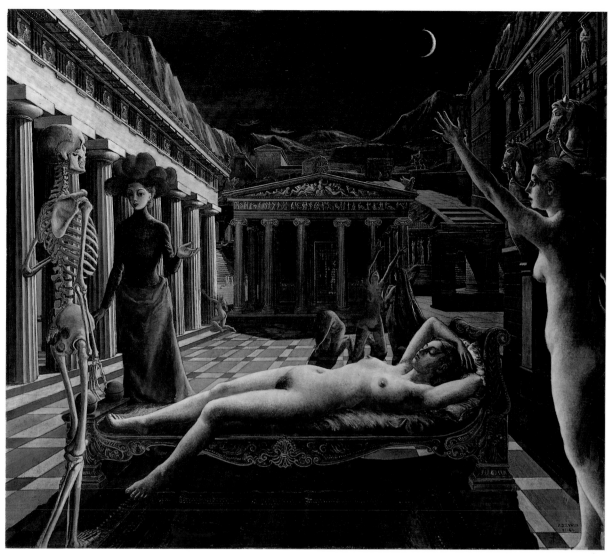

Paul Delvaux b.1897
La Vénus Endormie (Sleeping Venus) 1944

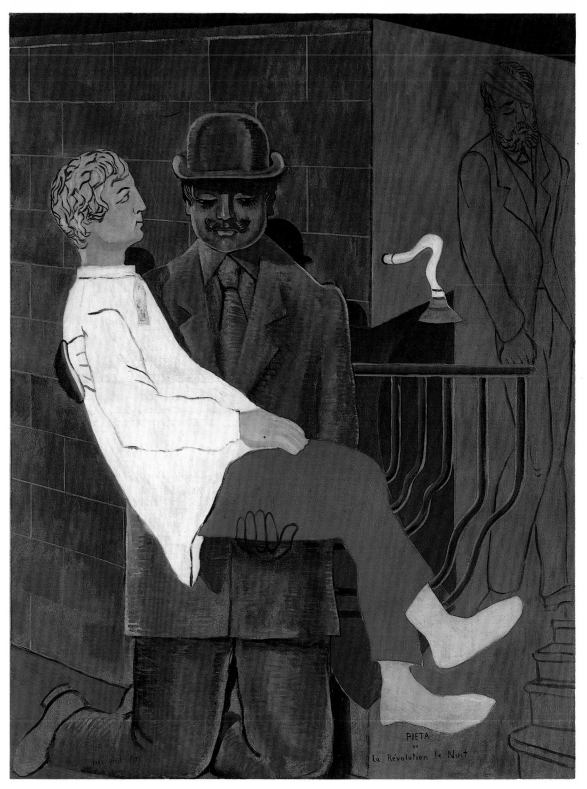

Max Ernst 1891–1976

40 *Pietà or Revolution by Night 1923*

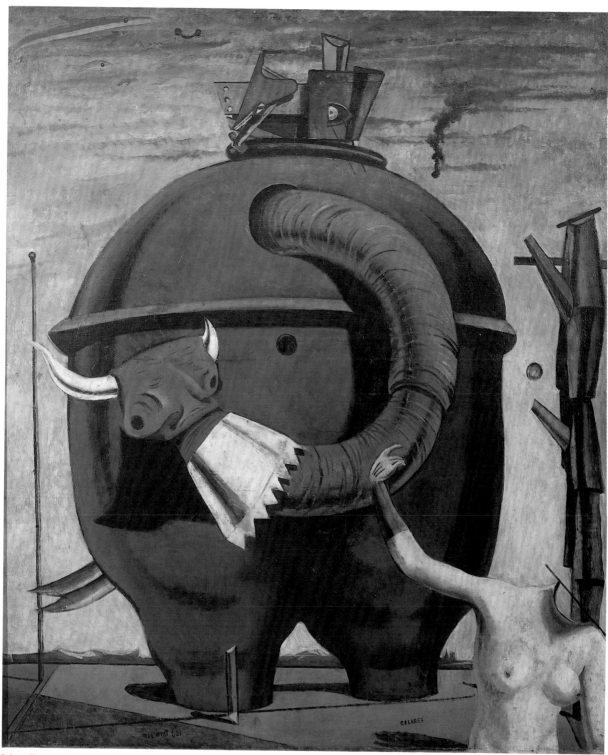

Max Ernst 1891–1976
Celebes 1921

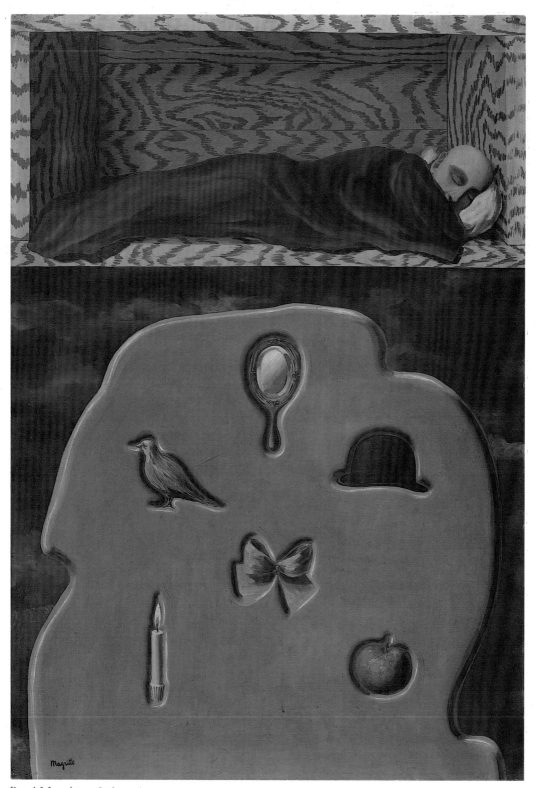

René Magritte 1898–1967

42 Le Dormeur Téméraire (The Reckless Sleeper) 1927

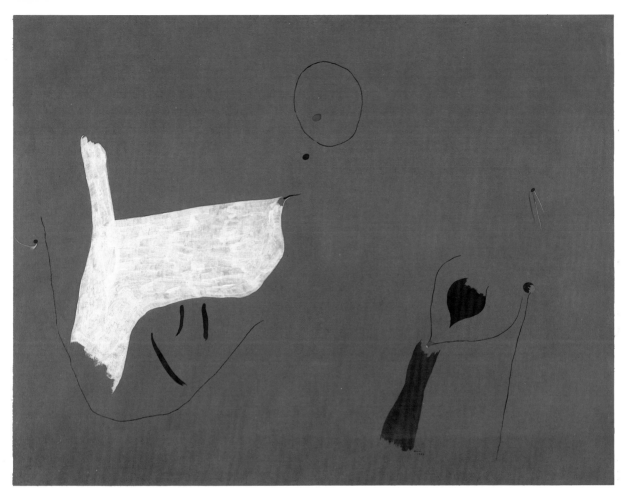

Joan Miró 1893–1983
Peinture (Painting) 1927

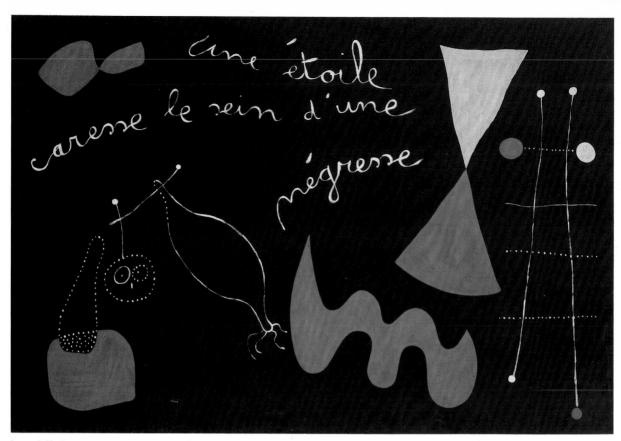

Joan Miró 1893–1983
A Star Caresses the Breast of a Negress
(Painting Poem) 1938

Sir Roland Penrose 1900–1984
Portrait 1939

Pablo Picasso 1881–1973
Les Trois Danseuses (Three Dancers) 1925

46

BIBLIOGRAPHY

1 Alexandrian, Sarane. *Surrealist art.* London: Thames and Hudson 1969.

2 Breton, André. *Manifestoes of Surrealism.* Ann Arbor (Mich): University of Michigan Press 1969.

3 Breton, André. *Surrealism and Painting.* London: Macdonald 1972 (original French ed 1928, repr 1965).

4 Breton, André. *What is Surrealism?* tr David Gascoyne. London: Faber and Faber 1936 (original French ed 1934).

5 Breton, André. *What is Surrealism? : selected writings,* ed & introd by Franklin Rosemont. London: Pluto Press 1978.

6 Canterbury, Herbert Read Gallery. *Surrealism in England, 1936 and after: an exhibition to celebrate the 50th anniversary of the First International Surrealist Exhibition in London in June 1936* catalogue of exhibition May 1986, texts by Michel Remy, Duncan Scott, Toni del Renzio.

7 Cardinal, Roger, & Robert Stuart Short. *Surrealism, permanent revelation.* London: Studio Vista/Dutton Pictureback 1970.

8 Chadwick, Whitney. *Women artists and the Surrealist movement.* London: Thames and Hudson 1985.

9 Chicago, Museum of Contemporary Art. *In the mind's eye: Dada and Surrealism* (catalogue of exhibition Dec 1984–Jan 1985, ed by Terry Ann R. Neff, texts by Dawn Ades, Mary Mathews Gedo, etc). New York: Abbeville Press 1984.

10 Colchester, Minories. *A salute to British Surrealism, 1930–1950* catalogue of exhibition, Apr–May 1985; texts by George Melly, Michel Remy, Louisa Buck).

11 Gascoyne, David, *A short history of Surrealism.* London: Frank Cass 1935, repr 1936, 1970.

12 Leeds, Leeds City Art Galleries. *Angels of anarchy and machines for making clouds: Surrealism in Britain in the Thirties* catalogue of exhibition Oct–Dec 1986, texts by Alexander Robertson, Michel Remy, Mel Gooding, Terry Friedman, incl transcript of catalogue of *The International Surrealist Exhibition,* New Burlington Galleries, London June–July 1936.

13 London, Arts Council. *Dada and Surrealism Reviewed* catalogue of exhibition in Hayward Gallery Jan–Mar 1978, text by Dawn Ades, introd by David Sylvester, supplementary essay by Elizabeth Cowling.

14 London, Mayor Gallery. *British Surrealism fifty years on: an exhibition to celebrate the half century of the International Surrealist Exhibition held at the New Burlington Galleries in Burlington Gardens, June 11th to July 4th 1936* catalogue of exhibition Mar–Apr 1986, introd by Michel Remy.

15 Nadeau, Maurice. *The history of Surrealism.* London: Jonathan Cape 1968 original French ed 1945.

16 New York, Museum of Modern Art. *Fantastic art, Dada, Surrealism* catalogue of exhibition Dec 1936–Jan 1937, text by Alfred H. Barr Jr, revised ed 1947.

17 New York, Museum of Modern Art. *Dada, Surrealism and their heritage* catalogue of exhibition March–June 1968, text by William S. Rubin.

18 Read, Herbert (ed). *Surrealism* texts by André Breton, Hugh Sykes Davies, Paul Eluard, Georges Hugnet. London: Faber and Faber 1936.

19 Remy, Michel. *Surrealism in England: towards a dictionary of Surrealism in England.* Nancy: Groupe-Edition Marges 1978.

20 Rosemont, Franklin. *André Breton and the first principles of Surrealism.* London: Pluto Press 1978.

21 Rubin, William S. *Dada and Surrealist art.* London: Thames and Hudson 1969.

22 Waldberg, Patrick. *Surrealism.* London: Thames and Hudson 1965.

23 Wilson, Simon. *Surrealist painting.* Oxford: Phaidon 1976, rev 1982.

EILEEN AGAR
London, Birch & Conran. *Eileen Agar: a retrospective* catalogue of exhibition July–Aug 1987, text by Andrew Lambirth.

HANS BELLMER
Alexandrian, Sarane. *Hans Bellmer.* New York: Rizzoli 1975 (original French ed 1972).

Webb, Peter, with Robert Short. *Hans Bellmer.* London: Quartet 1985.

ANDRÉ BRETON
Carrouges, Michel. *André Breton and the basic concepts of Surrealism.* Montgomery (Ala): University of Alabama Press 1974 (original French ed 1950).

ALEXANDER CALDER
Arnason, H. Harvard (introd). *Calder.* London: Thames and Hudson 1971.

Calder, Alexander. *Calder: an autobiography with pictures.* New York: Pantheon Books 1966.

GIORGIO DE CHIRICO
Munich, Haus der Kunst. *Giorgio de Chirico* catalogue of exhibition, Nov 1982–Jan 1983, travelling to Paris, Centre Georges Pompidou, Feb–Apr 1983, text by William Rubin, Wieland Schmied, Jean Clair.

New York, Museum of Modern Art. *De Chirico* catalogue of exhibition, Apr–June 1982, travelling to London, Tate Gallery, Aug–Oct 1982, text ed by William Rubin.

ITHELL COLQUHOUN
Newlyn, Newlyn Orion Galleries. *Surrealism: paintings, drawings, collages 1936–1976 [by] Ithell Colquhoun* catalogue of exhibition Feb–Mar 1976, text by the artist.

SALVADOR DALI
Ades, Dawn. *Dalí.* London: Thames and Hudson 1982.

Dalí, Salvador. *Dalí by Dalí.* New York: Harry N. Abrams 1974 (original French ed 1970).

Dalí, Salvador. *Diary of a genius.* London: Hutchinson 1966 (original French ed 1964).

Dalí, Salvador. *The secret life of Salvador Dalí.* London: Vision Press 1949.

London, Tate Gallery. *Salvador Dalí* catalogue of exhibition May–June 1980; text by Simon Wilson.

PAUL DELVAUX
Butor, Michel, Jean Clair, Suzanne Houbart-Wilkin. *Delvaux.* Brussels: Cosmos 1975.

MAX ERNST
Ernst, Max. *Beyond painting, and other writings by the artist and his friends.* New York: Wittenborn, Schultz 1948.

London, Arts Council. *Max Ernst* catalogue of exhibition in Tate Gallery, Sept–Oct 1961.

Russell, John. *Max Ernst, life and work.* London: Thames and Hudson 1967.

Schneede, Uwe M. *The essential Max Ernst.* London: Thames and Hudson 1972.

ALBERTO GIACOMETTI
Hohl, Reinhold. *Alberto Giacometti: sculpture, painting, drawing.* London: Thames and Hudson 1972.

Lord, James. *Giacometti, a biography.* New York: Farrar, Straus & Giroux 1985.

ADOLF GOTTLIEB
Washington, Corcoran Gallery of Art. *Adolf Gottlieb: a retrospective* catalogue of exhibition, Apr–June 1981, text by Lawrence Alloway, Mary Davis MacNaughton. New York: The Art Publisher, Adolph and Esther Gottlieb Foundation, 1981.

PAUL KLEE
Geelhaar, Christian. *Paul Klee, life and work.* Westbury (NY): Barron's 1982 (original German ed 1974).

Klee, Paul. *The thinking eye: the notebooks of Paul Klee,* ed Jurg Spiller. London: Lund Humphries, 1961 (original German ed 1956).

Klee, Paul. *The diaries of Paul Klee 1898–1918* ed Felix Klee. London: Peter Owen 1965 (original German ed 1957).

F. E. McWILLIAM
Belfast, Ulster Museum. *F. E. McWilliam* catalogue of exhibition Apr–May 1981, text by Judy Marle, T P Flanagan. Belfast: Arts Council of Northern Ireland, Dublin: An Chomhairle Ealaion 1981.

CONROY MADDOX
London, Camden Arts Centre. *Conroy Maddox [and] Surrealism unlimited 1968–1978* catalogue of exhibition, Jan–Mar 1978, text by Robert Short.

RENE MAGRITTE
Calvocoressi, Richard. *Magritte.* Oxford: Phaidon 1979, rev 1984.

Dopagne, Jaques. *Magritte.* London: Eyre Methuen 1979 (original French ed 1977).

Gablik, Suzi. *Magritte.* London: Thames and Hudson 1970.

Magritte, Rene. *Collected writings.* London: John Calder 1987.

ANDRE MASSON
Hahn, Otto. *Andre Masson.* London: Thames and Hudson, 1965.

JOAN MIRÓ
London, Arts Council. *Miró* catalogue of exhibition in Tate Gallery, Aug–Oct 1964; text by Roland Penrose.

Penrose, Roland. *Miró.* London: Thames and Hudson 1970.

Soby, James Thrall. *Joan Miró.* New York: Museum of Modern Art 1959.

HENRY MOORE
Berthoud, Roger. *The life of Henry Moore.* London: Faber and Faber 1987.

Clark, Kenneth. *Henry Moore drawings.* London: Thames and Hudson 1974.

Finn, David. *Henry Moore: sculpture and environment.* London: Thames and Hudson 1977.

Grohmann, Will. *The art of Henry Moore.* London: Thames and Hudson 1960.

Hedgecoe, John (ed). *Henry Moore.* London: Ebury Press 1986.

Moore, Henry. *Henry Moore: sculpture and drawings [catalogue raisonné],* introd Herbert Read. 6 vols. London: Lund Humphries, A Zwemmer, 1944 (rev 1957 as vol 1, to cover years 1921–1948, ed David Sylvester), 1955 (rev 1965 & 1986 as vol 2: 1949–1954, ed Alan Bowness), 1965 (vol 3: 1955–1964, ed Alan Bowness; rev 1986), 1977 (vol. 4; 1964–1973, ed Alan Bowness), 1983 (vol 5: 1974–1980, ed Alan Bowness), 1987 (vol 6: 1980–1986, ed Alan Bowness).

Russell, John. *Henry Moore.* London: Allen Lane 1968; revised ed Harmondsworth (Middx): Penguin 1973.

PAUL NASH
Causey, Andrew. *Paul Nash.* Oxford: Oxford University Press 1980.

ROLAND PENROSE
London, Arts Council. *Roland Penrose* catalogue of touring exhibition opening in King's Lynn, July–Aug 1981, text by Norbert Lynton.

Penrose, Roland. *Scrap book 1900–1981.* London: Thames and Hudson *1981.*

FRANCIS PICABIA
Borras, Maria Lluisa. *Picabia.* London: Thames and Hudson 1985.

Camfield, William A *Francis Picabia: his art, life and times.* Princeton (NJ): Princeton University Press 1979.

PABLO PICASSO
Ashton, Dore (ed.). *Picasso on art; a selection of views.* London: Thames and Hudson 1972.

Barr, Alfred H, Jr. *Picasso; fifty years of his art.* New York: Museum of Modern Art 1946.

London, Arts Council. *Picasso: sculpture, ceramics, graphic work* catalogue of exhibition in Tate Gallery, June–Aug 1967, text by Roland Penrose.

McCully, Marilyn (ed). *A Picasso anthology: documents, criticism, reminiscences.* London: Arts Council of Great Britain 1981.

O'Brien, Patrick. *Pablo Ruiz Picasso.* London: Collins 1976.

Penrose, Roland. *Picasso, his life and work.* London; Victor Gollancz, 1958, rev 1971 (Penguin), 1981 (Granada).

JACKSON POLLOCK
Frank, Elizabeth. *Pollock.* New York: Abbeville 1983.

Friedman, B H. *Jackson Pollock: energy made visible.* New York: McGraw-Hill 1972.

O'Connor, Francis Valentine, & Eugene Victor Thaw (ed.). *Jackson Pollock: a catalogue raisonné of paintings, drawings and other works.* 4 vols. New Haven, London: Yale University Press 1978.

YVES TANGUY
Tanguy, Yves. *Yves Tanguy: un receuil de ses oeuvres/a survey of his works.* New York: Pierre Matisse 1963.